POSTCARD HISTORY SERIES

Huntington

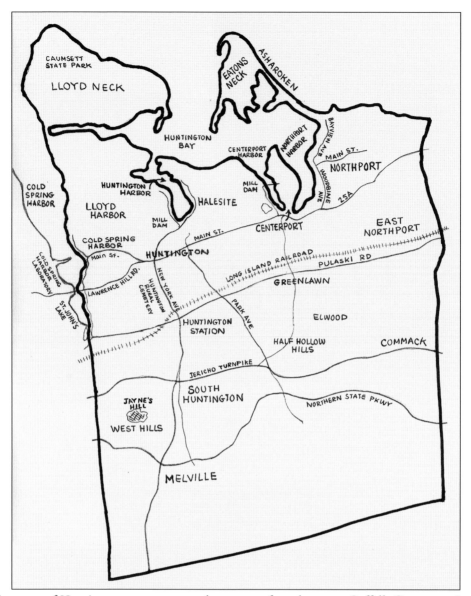

The town of Huntington encompasses a large area of northwestern Suffolk County on Long Island, New York. The Long Island Sound is to its north and Nassau County to its west. It consists of four incorporated villages—Asharoken, Huntington Bay, Lloyd Harbor, and Northport—and several hamlets that are seen on the map above. (Author's collection.)

ON THE FRONT COVER: This is looking at the north corner of Main Street and New York Avenue, the main intersection of Huntington village. Today, Book Revue, Long Island's largest and best-ranked independent bookstore, sits in the center of this image to the left of the open barn door. (Author's collection.)

ON THE BACK COVER: This 1910 "Greetings From Huntington, L.I." postcard features highlights of Huntington, including the Nathan Hale rock, Main Street, the steamer *Huntington*, the Memorial Library, Lloyds Neck lighthouse, and Walt Whitman's birthplace. (Author's collection.)

POSTCARD HISTORY SERIES

Huntington

Patricia J. Novak

ARCADIA
PUBLISHING

Published by Arcadia Publishing
Charleston, South Carolina

Printed in the United States of America

Library of Congress Control Number: 2017954619

For all general information contact Arcadia Publishing at:
Telephone 843-853-2070
Fax 843-853-0044
E-mail sales@arcadiapublishing.com
For customer service and orders:
Toll-Free 1-888-313-2665

Visit us on the Internet at www.arcadiapublishing.com

CONTENTS

ACKNOWLEDGMENTS

Many thanks to Teresa Schwind, assistant director of the Huntington Public Library, for letting me run loose in the Mary Talmage Local History Room to get my bearings at the onset of this project. What I discovered from my two-hour exploration was that there are inconsistencies in historical details in various books already published about Huntington. Therefore, I knew I had to find primary sources to validate my own information. With the Huntington Historical Society closed for renovations, and the archivists unavailable for research as they organize their new space, I had to draw my material almost exclusively from period newspapers, such as the *Brooklyn Daily Eagle*, the *Long-Islander*, the *New York Times*, *Newsday*, the *Northport Journal*, and the *Long Island Traveler*.

Thanks to Liz DiMaulo, whose eagle eyes for curbs, telephone poles, bump-outs, chimneys, street gradients, balustrades, columns, and stop signs in the postcards helped identify the many homes that are still standing today. In addition, her photographic and grammatical skills should not go unmentioned.

John C. Miller, a deltiologist from Maryland, had some fine real photo postcards of Huntington that supplemented my collection perfectly. They're mine now! Thanks, John.

Many thanks to the team at Arcadia, especially Erin Vosgien, acquisitions editor, for believing in my project, and Caroline Anderson, my editor, for taking me through the writing process from cover to cover. My brother, Michael J. Novak, has traveled down the Arcadia path pursuing his own passion for history, and my feeling is that if he could write an Arcadia book, so too can I! So thanks, Mike.

Finally, this journey has taken me back in time to meet so many Huntingtonians who have contributed in great ways in making Huntington a thriving township. These visionaries, men and women, contributed their time, land, and money to provide schools, churches, a hospital, parks, beaches, and infrastructure that we take for granted today. It has been an honor to meet them all during my research.

All of the images in this book are from my personal collection.

INTRODUCTION

Low taxes! One of the best Schools in N.Y. State! Eight churches comprising all the leading denominations! Good Society! Good Stores! Lovely Hills and Valleys, and Beautiful Building Sites commanding a view of Long Island Sound, the Connecticut Shore and the Atlantic Ocean! Good Boating and fishing! Clear and pure air, and absolute freedom from Malaria and Mosquitoes! Good communication with New York City and Brooklyn by Railroad, and one of the fastest Steamboats that travels out of N.Y. City, and regular Steam Communication with the Connecticut Cities!

—Charles E. Shepard, *Long-Islander*, April 20, 1877.

Charles Shepard's glowing assertion of Huntington's virtues was an inducement to invite "overtaxed and wearied" metropolis residents to "one of the prettiest villages within forty miles of New York City." Shepard describes Huntington and its environs in the very way the postcards in this volume depict it: idyllic settings with great facilities and infrastructure, and a rich history worth honoring and documenting for generations to come.

The early history of the town of Huntington is well documented thanks to the dedicated individuals throughout the centuries who maintained the Indian deeds, mortgages, Revolutionary War papers, and a wealth of other manuscripts that can trace the town from its beginnings to the present day. In 1646, a tract of land known today as Eatons Neck was sold to Theophilus Eaton, the governor of New Haven, Connecticut, by Indians in that area. However, the legitimacy of that purchase has been called into question on more than one occasion. In 1653, land was conveyed to actual settlers within the town. That deed (the "First Purchase") is preserved in the Town of Huntington's archives.

Just before the 1800s, the town's reach extended from the Long Island Sound all the way south to the Great South Bay, west to Cold Spring Harbor, and east to the Smithtown border, for 160 total square miles. In 1872, the town of Babylon was established on the southern border and therefore seceded from Huntington. The town has changed its borders and jurisdictions on numerous occasions, but just before the time of the oldest of these postcards, the boundaries were settled to what they are today. The town has four incorporated villages with their own mayors and trustees: Asharoken, Huntington Bay, Lloyd Harbor, and Northport. The more prominent hamlets within the town are Centerport, Cold Spring Harbor, Dix Hills, East Northport, Eatons Neck, Elwood, Fort Salonga, Greenlawn, Halesite, Huntington, Huntington Station, Melville, South Huntington, and West Hills. The relative locations of these villages and hamlets can be found on the map at the front of the book.

Many of the hamlet names of today were known differently by earlier townspeople. South Huntington was Long Swamp; Huntington Station was Fairground; Sweet Hollow is now Melville; Eatons Neck was also Gardiner's Neck; Centerport was formerly Little Cow Harbor; Northport was Great Cow Harbor; Commack was Winnecomac, and Lloyd Neck was Horse Neck (for obvious reasons, visually). Cold Spring Harbor was just Cold Spring at one time. However, since there is also a Cold Spring in upstate New York, "Harbor" was added to the hamlet's name. The earliest postcards of area hamlets would have Cold Spring, Centreport (note the spelling), and Fairground or Fair Ground instead of their more familiar names today.

The town of Huntington has four harbors, and each has a unique history. Although all of the harbors built ships, Northport Harbor was the center of shipbuilding prior to the shift from wooden to steel hulls. Centerport's harbor lacks the depth for the largest ships, so it became a resort area with small hotels, summer cottages, and a large public beach. A gristmill and dam on Mill Dam Road provided flour for the eastern part of the township. Huntington Harbor was all about commerce and trade with New York and Connecticut, which waned with the introduction of alternative means of transportation. Huntington Harbor had gristmills, sawmills, and lumberyards. With the abundance of clay, there were several brickyards and a pottery factory. The beautiful bay was perfect for pleasure boating. The capacious Cold Spring Harbor was a whaling port from the 1830s to the 1860s. It too had several mills and an abundance of fresh water from streams. It also had a brickyard. Oyster cultivation and clamming were present in all four harbors, and commercial fishing in Huntington predated any industry there.

In 1868, when the Long Island Rail Road Company extended its rails out to Northport, passengers rode in from the New York City area to enjoy the summer season with cool breezes from the harbors and the bay. At the time of these postcards, the automobile arrived on the scene, bringing even more visitors. Huntington and its environs became a destination. Wealthy individuals such as Marshall Field III (Lloyd Neck), Walter Jennings (Lloyd Neck), William K. Vanderbilt (Centerport), Louis Comfort Tiffany (Cold Spring Harbor), George McKesson Brown (Huntington), William J. Matheson (Lloyd Neck), and Juliana Ferguson (Huntington) built summer "Gold Coast" mansions overlooking the harbors. The largest estate in the township was Oheka Castle, built by financier Otto Kahn. Although not directly on a harbor, it was constructed on a built-up hill that, at the time (1914–1918), would have had a view of Cold Spring Harbor.

In 1903, when Huntington was celebrating its 250th anniversary, the postcard was nearing its peak in popularity. Over seven billion postcards passed through post offices worldwide in 1905 alone. The picture postcard itself is a historically and socially valuable communication that not only captures a moment in time visually but also may add insightful information from its sender or publisher that can convey a new and unique perspective on a scene or event that a photograph alone cannot provide. Nearly all of the postcards in this book were published during three distinct eras of postal history regulations: the Private Mailing Card Era (1898–1901), the Undivided Back Era (1901–1907), and the Divided Back Era (1907–1915). These eras correspond with the growth of Huntington in the way Charles Shepard envisioned it and in the way the picture postcard and photographic pioneers of the town, like Thomas Y. Gildersleeve, James V. Feather, F. Leek, David W. Trainer, and F.E. Shadbolt, to name a few, captured it for us to marvel at over a century later.

One

EDUCATION AND WORSHIP

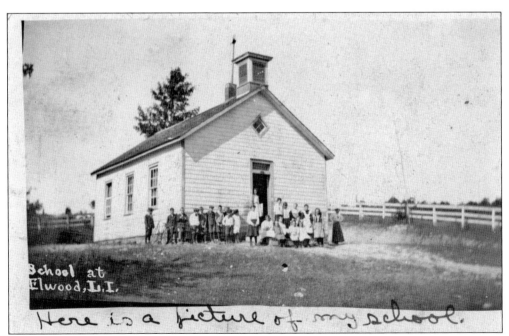

School at
Elwood, L.I.

Here is a picture of my school.

The sender of this 1907 postcard of Elwood School was Anna R. Purtill, a 1906 graduate (one of four in her class) of Huntington High School. In September 1907, she started her career as a teacher at this school. She is likely the young lady standing in the doorway. She went on to teach throughout the township and in the Hicksville school system.

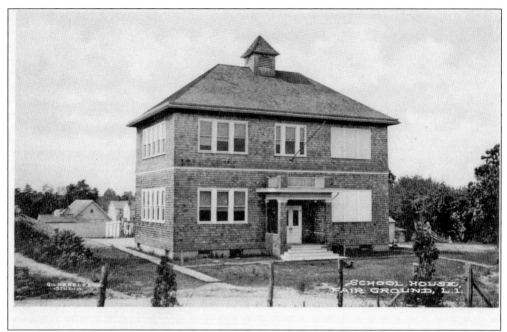

The Fair Ground School was built in 1906 at a cost of $6,500 and closed in 1913, when the Lowndes Avenue Grammar School was built. It had four rooms for primary classes. Later, it was used as a post office and a VFW hall before being demolished as part of the Huntington Station Renewal Project. This school was also referred to as the Station School and the School Street School.

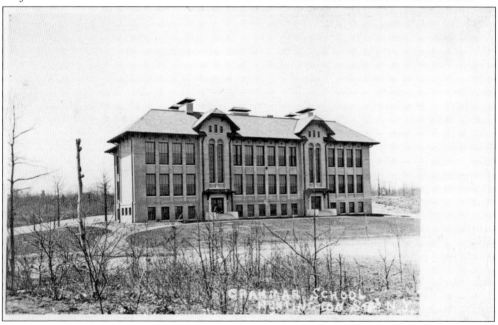

This postcard of Lowndes Avenue Grammar School predates Arbor Day in 1914, when 40 maples were planted on the property. It was a modern structure for its day. In 1927, it was expanded and renamed Roosevelt School. In 1968, the town paid $465,000 for the then abandoned building and $19,000 to demolish it that same year as part of the Huntington Station Renewal Project.

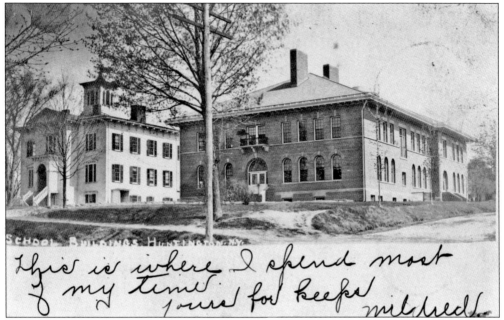

This is where I spend most of my time. Yours for keeps, Mildred.

The Huntington Union Free School District was formed in 1857. The Huntington Union School (above left) opened in 1858 at a cost of $6,000. The wooden structure was painted white, much to the displeasure of some taxpayers. The Main Street School (above right), which opened on February 26, 1900, with 225 pupils, was designed by Cady, Berg, and See, the same architectural firm that built the first Metropolitan Opera House in New York and Huntington's Trade School. In late 1908, the Union School was torn down to make way for a new Huntington High School (below left), which was dedicated on January 31, 1910. It closed in 1952 after the new Huntington High School on Oakwood Road opened. The two remaining schools in the postcard below were annexed to form the current Huntington Town Hall.

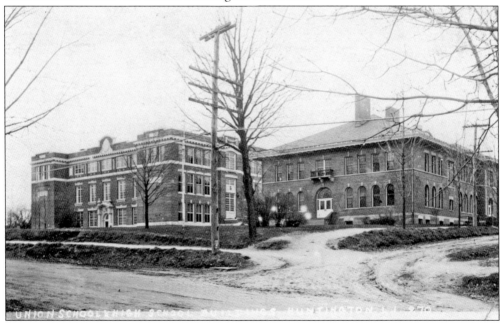

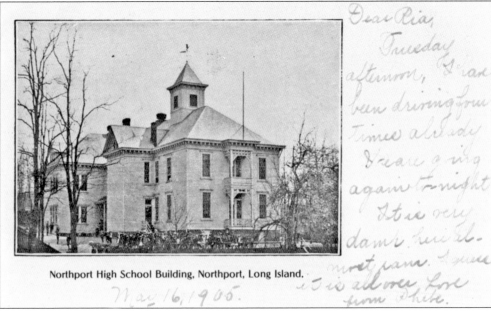

Northport High School Building, Northport, Long Island.

May 16, 1906.

Dear Ria,
Tuesday
afternoon, I have
been driving four
times already
I am going
again tonight
It is very
damp here al-
most pours. I mean
it is all over. Love
from Phebe.

The School Street School (above) in Northport was built in 1880. The first high school department graduating class at this facility was in 1900. By 1912, suggestions were first raised that a new school be built to alleviate overcrowding. In December 1923, advertisements popped up in local papers for over two dozen bricklayers to begin work on the new Northport High School (below) on Laurel Avenue. In 1924, all grades were moved to the new school, and in March 1925, the dedication and official opening took place. The School Street School was eventually torn down. Once again, with tremendous population growth in the Northport–East Northport district, a new Northport High School on Laurel Hill Road opened in 1966. The previous high school is now a middle school.

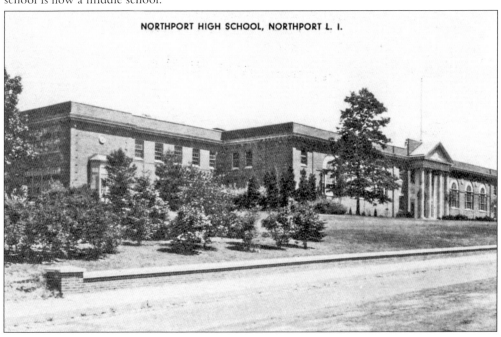

NORTHPORT HIGH SCHOOL, NORTHPORT L. I.

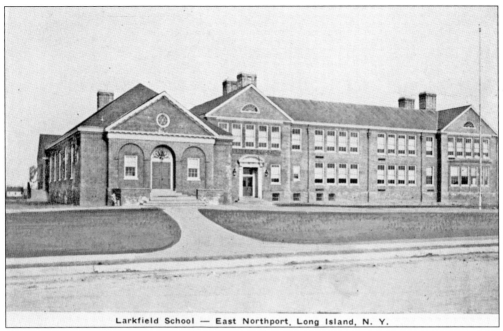

Larkfield School — East Northport, Long Island, N. Y.

The Larkfield School in East Northport was built entirely by local laborers with a grant from the Public Works Administration. The architect was James Van Alst of Centerport. After a short parade by local businesses and organizations, the cornerstone was laid on July 2, 1938. The elementary-aged children moved into the new school in early November 1938.

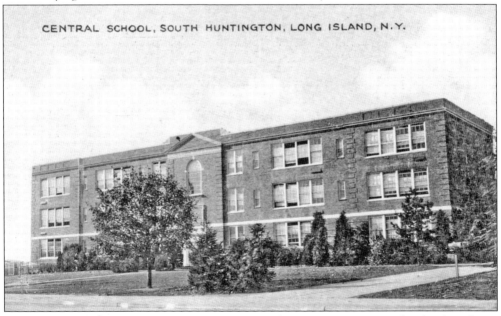

CENTRAL SCHOOL, SOUTH HUNTINGTON, LONG ISLAND, N.Y.

Central High School opened in 1929. August H. Galow, a Huntington High School graduate, was the architect. It later became South Huntington High School and then Central Elementary School. The first South Huntington Public Library, which opened in 1961, was located in the basement at the southeast (left) corner. The building still stands today behind a modern facade near the corner of New York Avenue and Jericho Turnpike.

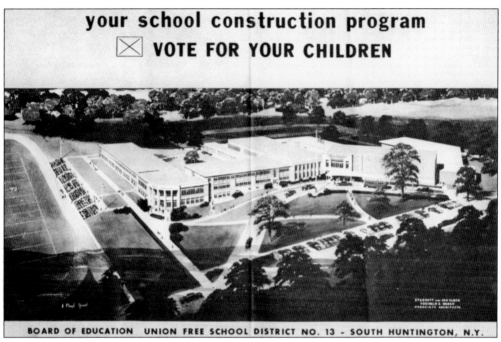

After World War II, there was a population explosion in Huntington Station, and as a result, several new public schools were needed. In 1954, a four-page proposal for the construction of four new schools was distributed in order to justify the ambitious project and garner the support of taxpayers. The proposal included three elementary schools (Birchwood, Maplewood, and Oakwood) and one junior-senior high, Walt Whitman High School. The total proposed cost to build and outfit the new schools was a remarkable $5,766,000. By 1965, Walt Whitman High School had an additional north wing, and there were nine elementary schools (Birchwood, Oakwood, Central, Beverly, Countrywood, Silas Wood, Maplewood, West Hills, and Pidgeon Hill) and two junior high schools (Memorial and Henry L. Stimson) operating in District 13.

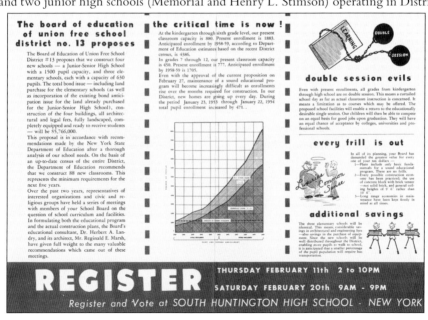

14

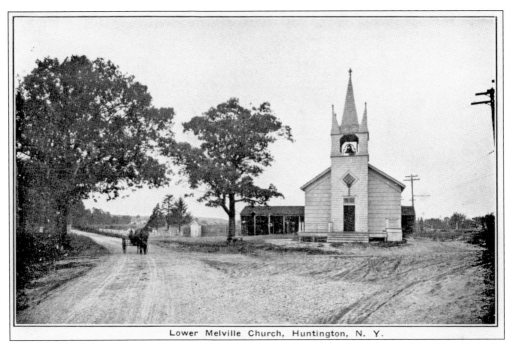

Lower Melville Church, Huntington, N. Y.

The Lower Melville Methodist Episcopal Church, also known as the "Little White Church in the Wildwood," is located at the far southwest corner of the town of Huntington. It was built in 1810. Many different religious and nonsectarian groups have held meetings in this church, including a Jamaica unit of the Ku Klux Klan. The building still stands, looking very much the same.

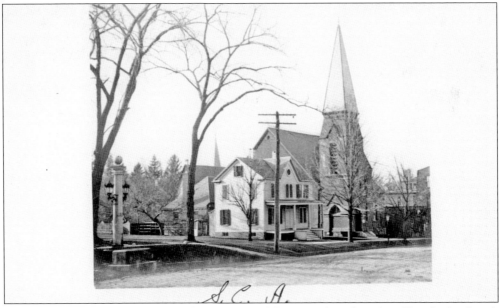

After the 1888 fire in Huntington village destroyed the Second Presbyterian Church, the church in this postcard was built. In 1899, New York state assemblyman Erastus F. Post introduced a bill to change the name of the church to the Central Presbyterian Church. This building and the rector's house next door no longer exist, but the third Presbyterian church built on the same plot of land still stands.

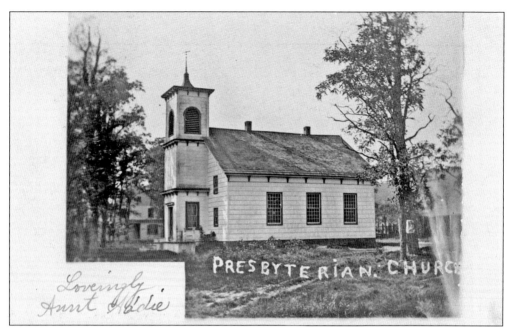

The Presbyterian Church of Sweet Hollow sits in Melville near the southern border of Huntington. The building was completed on July 14, 1829, and opened two days later. Local residents, principally the Baylis and Smith families, wanted to establish a church in their community. Previously, they made the long trip to Huntington village to worship at the Old First Presbyterian Church.

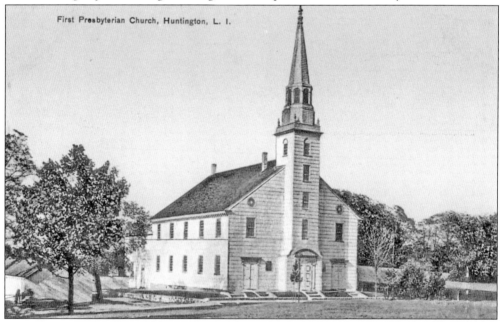

The oldest church in Huntington (a Congregational church) was built in 1658. A new church was erected in 1715 but destroyed in 1782 by British troops occupying Huntington who used its wood to build Fort Golgotha on the Old Burying Ground. The current Old First Presbyterian Church was erected on the same site in 1784. The church bell, taken by the British, is currently on display in the church.

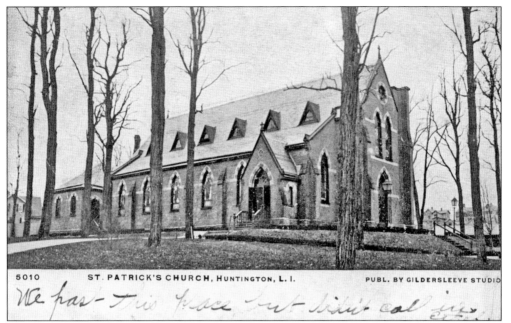

5010 ST. PATRICK'S CHURCH, HUNTINGTON, L. I. PUBL. BY GILDERSLEEVE STUDIO

We pas - This place but didn't cal in

The first Catholic church in Huntington opened its doors on August 15, 1849, and stood off West Neck Road at the site of the present St. Patrick's Cemetery. Fr. Jeremiah J. Crowley was the first resident pastor. When the church burned in 1866, Father Crowley had a new church built on Main Street and Ackerman Place at a cost of $29,000. It was dedicated on June 27, 1869.

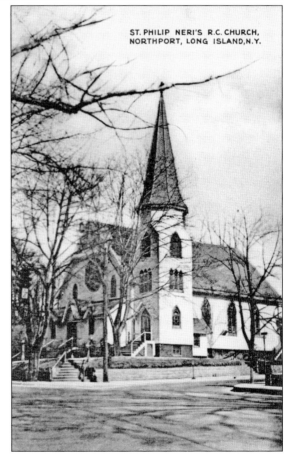

ST. PHILIP NERI'S R.C. CHURCH, NORTHPORT, LONG ISLAND, N.Y.

Prior to 1895, Northport Catholics made the six-mile trek to Huntington's St. Patrick's Church to worship. On September 10, 1894, the cornerstone was laid for the St. Philip Neri Church in Northport. The dedication of the frame building with the tile roof was on November 3, 1895. Bishop Charles McDonnell from Brooklyn blessed the church. The building was replaced in 1970 by a larger brick structure.

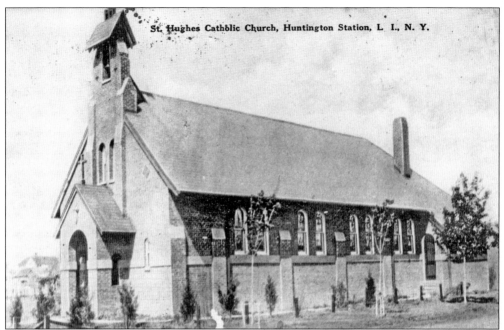

In 1907, the St. Hugh of Lincoln Church began as a mission of St. Patrick's in Huntington. The parish is named after Brooklynite Hugh McLaughlin. A generous gift of $8,500 by his widow helped fund the erection of the Hugh McLaughlin Memorial Chapel, which was dedicated in 1909 at its current location on New York Avenue at Ninth Street in Huntington Station.

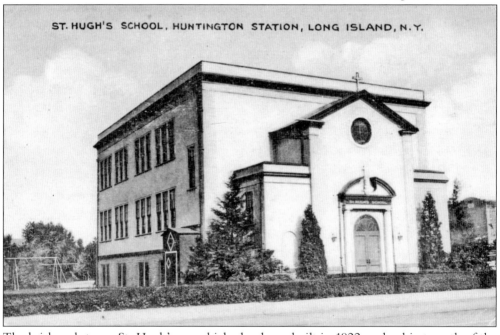

The brick and stucco St. Hugh's parochial school was built in 1922 on land just north of the main church. James F. Mahon was the architect. It was staffed by the Dominican Sisters. The school basement was used for church services until the main chapel was expanded in 1952. This school was later replaced by a larger facility.

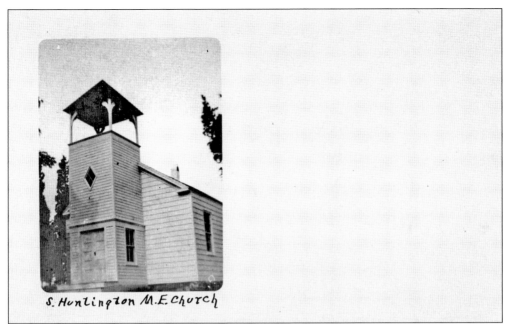

S. Huntington M.E. Church

Between 1906 and 1917, there were two South Huntington Methodist Episcopal Churches operating at different times. In 1907, this church and the Methodist Episcopal churches in West Hills, Cold Spring Harbor, and Woodbury were under the charge of the Rev. E.S. Jackson. By 1909, the congregation desired a new building in the Fairground area due to extensive repairs needed on the previous edifice. It was built in 1912.

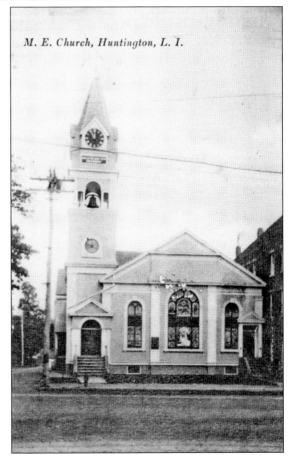

M. E. Church, Huntington, L. I.

With the help of architect George W. Kramer, the Methodist church on the north side of Main Street, Huntington—near what is Clinton Street today—was redesigned and expanded to what is seen in this postcard. The prominent clock became a centerpiece on Main Street. Beneath it is a motto by Rev. Edward Bickersteth: "Time is the seed-plot for eternity." There is no longer a church at that Main Street site.

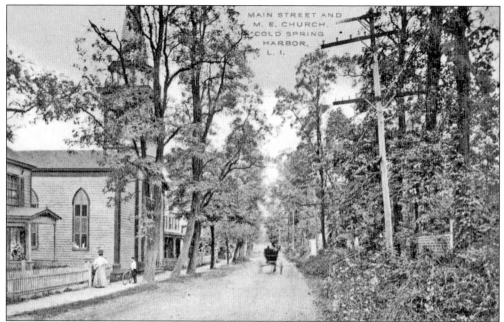

The Cold Spring Harbor Methodist Episcopal Church on Main Street was dedicated on October 23, 1842. The church still stands, although changes have been made to the building. Most notably, the steeple (above) was replaced with a belfry. In the postcard below, the interior of the church is decorated for the June 9, 1908, marriage of Abby E. Newman and Rev. Edgar S. Jackson, the pastor of the church. The sender of the postcard wrote, "This will give you some idea of what was done, the decorations were entirely, you might say of oak branches, laurel and ferns. It was the most impressive wedding I ever saw. This was true because of the great beauty of the bride and groom." Reverend Jackson was later appointed pastor of the Methodist Episcopal church in Maspeth in April 1910.

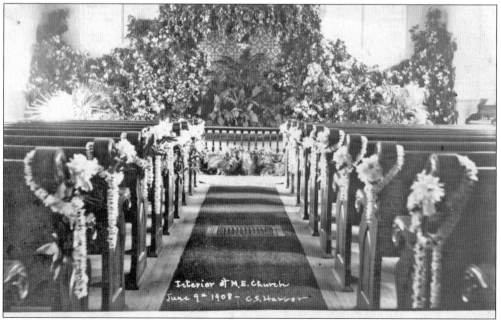

St. Paul's Methodist Episcopal Church on Main Street, Northport, was dedicated on August 24, 1873. It has a Corinthian belfry and tower. The church bell was a gift from Harvey Bishop, whose farm land was used for part of the Northport Rural Cemetery. The new church cost $18,222.50, which was raised entirely by subscription. The church is still active today.

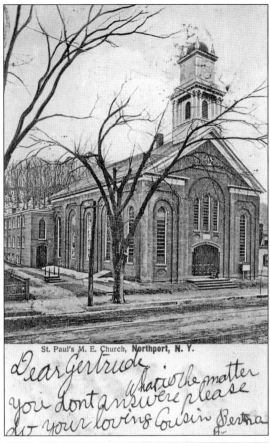

St. Paul's M. E. Church, Northport, N. Y.

Dear Gertrude you dont answere what is the matter please if your loving Cousin Bertha

In this 1909 postcard of the corner of Main and Church Streets, the Presbyterian church (1873) is on the right, and the old St. Philip Neri Catholic Church (1894) is at center. The latter wooden structure was replaced by a larger brick building in 1970. The wagon driving along the trolley tracks likely carried water or any of a number of substances used to reduce dust on the roads.

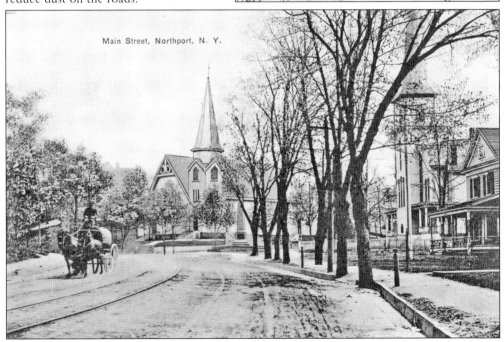

Main Street, Northport, N. Y.

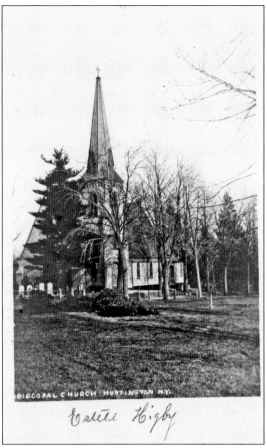

The first St. John's Church in Huntington was Anglican and was built in 1747 across from what is now Huntington Hospital. The growth in membership necessitated the construction of a larger facility (left). The second St. John's Episcopal Church, consecrated in 1862, was built on the same site as the previous church. It was severely damaged on April 24, 1905, when a careless tinsmith making repairs on the roof accidentally set it on fire with a lamp. The postcard below shows the interior of the second St. John's Church just months before the 1905 fire. With a stiff wind blowing away from the village, the ringing church bell could not be heard. Despite the damage, many of the pews in the postcard were saved and are still in use today in the third church.

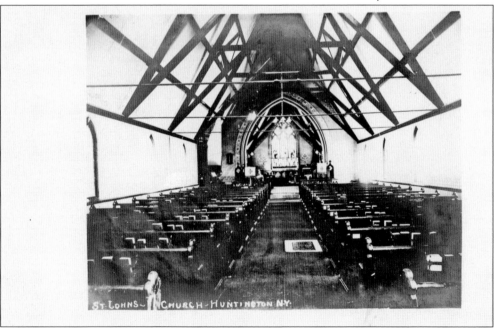

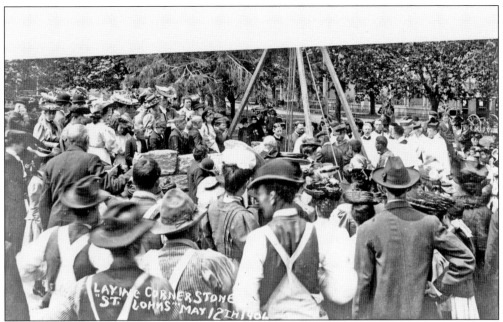

The parishioners recognized that in order to increase their membership and godly works, St. John's Church would need to move closer to the village center of Huntington. Parishioner Anna Paulding donated the land for the new building at the corner of Main and Prospect Streets. The Gothic Revival style was designed by noted church architect Henry Martyn Congdon, an Episcopalian himself. On May 12, 1906, the cornerstone, which was the same one used in the previous church, was laid on a pleasant Saturday morning by the Rev. Frederick Burgess, bishop of Long Island. The balding man at center left above has his hand on the first bricks. The third St. John's Church (below) was completed in 1907. The parish house is off to the left. This church, now in its second century, is still active.

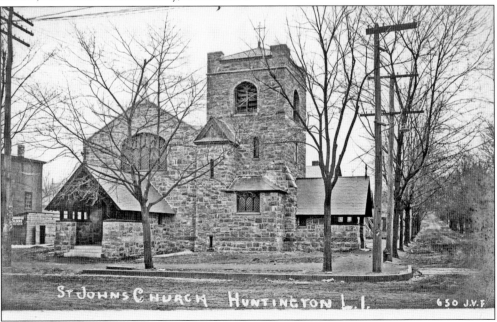

Mrs. Townsend.

Although most of Cold Spring Harbor lies in the township of Huntington, St. John's Church of Cold Spring Harbor sits just outside the town's border. This picturesque church was constructed in 1835 by Oliver Smith Sammis of Huntington. Part of the John Hewlett Jones property was sold with the stipulation that only a building affiliated with the Protestant Episcopal Society could be erected there.

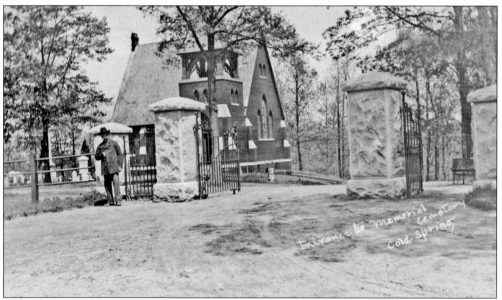

Entrance to memorial cemetery Cold Spring

St. John's Memorial Cemetery, associated with St. John's Church, is located about two miles west of the church. Several notable persons interred there include American painter Arthur Dove, Nobel Prize winner Alfred Hershey, financier and owner of Oheka Castle Otto Kahn, New York mayor John Lindsay, CBS founder William S. Paley, and Henry L. Stimson, secretary of state under Hoover. Sons of Frederick Law Olmsted designed the site.

After the sum of $1,500 was collected for the building fund, the cornerstone for the new Trinity Episcopal Church was laid in July 1889. Rev. Edgar L. Sanford was the rector of the small church on the north side of Main Street, Northport, on land originally provided by James Cockcroft. The church, slightly altered but still recognizable, still stands today. Enrico Caruso once sang in this church.

Emma Paulding ran a highly successful sewing school for girls in Huntington. The inclusion of boys brought craft variety and growth to the organization, requiring it to move to a larger facility. The wealthy Cornelia Prime purchased a lot on Main Street and donated it for the building of the trade school. It opened in 1905. Newly renovated, it is now the home of the Huntington Historical Society.

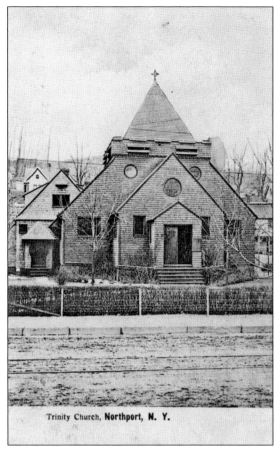

Trinity Church, **Northport**, N. Y.

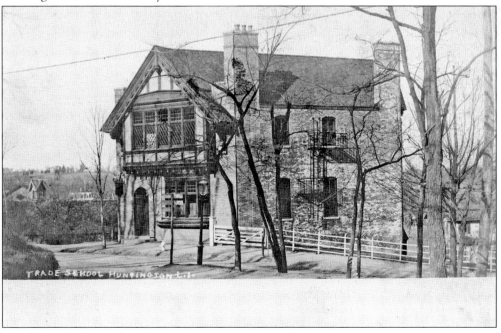

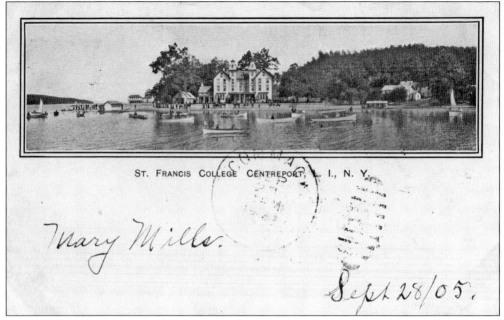

ST. FRANCIS COLLEGE CENTREPORT, L. I., N. Y.

Mary Mills.

Sept 28/05.

In the late 1890s, the Franciscan Brothers of the St. Francis College of Brooklyn purchased the Morris Chalmers property with its three-story boardinghouse on Centerport Harbor. They named the summer retreat Mount Alvernia. Over the years, additional houses and property were purchased, and the boardinghouse expanded. It was initially used as a school for brotherhood members only but eventually included the boys who attended St. Francis parochial schools.

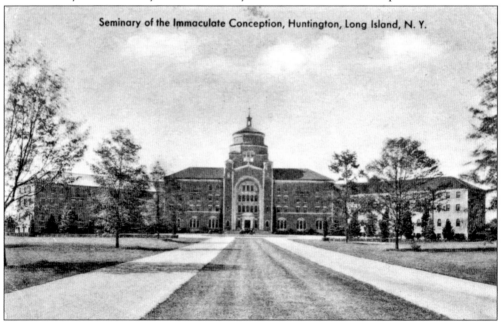

Seminary of the Immaculate Conception, Huntington, Long Island, N. Y.

The Seminary of the Immaculate Conception was founded in 1926, when Bishop Thomas E. Molloy of Brooklyn acquired a house and nearly 200 acres of property in Lloyd Harbor once belonging to the Conklin family. The building in this postcard was erected in 1928 and dedicated in 1930. It was first used for students seeking priesthood. Today it is used more for theological education.

Two

RESIDENCES AND RETREATS

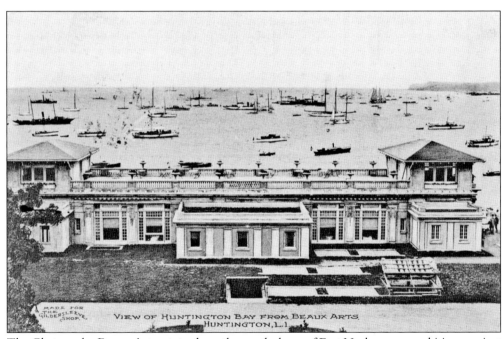

VIEW OF HUNTINGTON BAY FROM BEAUX ARTS.
HUNTINGTON, L.I.

The Chateau des Beaux Arts estate along the north shore of East Neck was an ambitious project conceived by the Bustanoby brothers, famous for their French restaurants in New York City. Their celebrity patrons included members of the Barrymore family, Lillian Russell, and Florenz Ziegfeld. The Casino, with its spectacular view of Huntington Bay, was built along the water's edge.

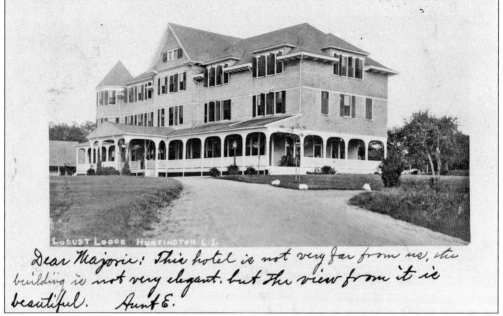

Dear Marjorie: This hotel is not very far from us, the building is not very elegant. but the view from it is beautiful. Aunt E.

The original hotel on the property, known as Clark House, belonged to the Clark family. The property was later purchased by the May family, and the renovated hotel was renamed Locust Lodge, after the beautiful grove of locusts on the property. The hotel could accommodate 60 to 70 guests in 30 sleeping apartments. In 1906, Frank May's widow sold the property to the Bustanoby brothers, who turned it into the Chateau des Beaux Arts.

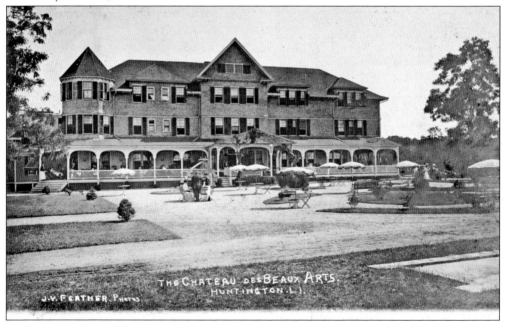

Compare this postcard of the newly christened Chateau des Beaux Arts to what the hotel looked like previously (above). The grounds were meticulously redesigned, and dozens of guests crowded the veranda. It looks as though little was done to the exterior, but the interior was elegantly refurnished with the same French decor found in the new Casino.

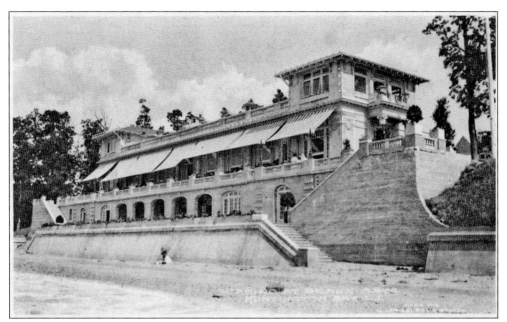

The original estate plan included the Casino des Beaux Arts with dining and social rooms (in the style of Louis XVI), a hotel with two wings and 120 sleeping rooms, and individual villas with garages throughout the property. A car ferry from Connecticut and a new speedway were envisioned to transport the "automobilists" to the lavish resort. The Casino opened in 1907, but the entire project was never fully realized.

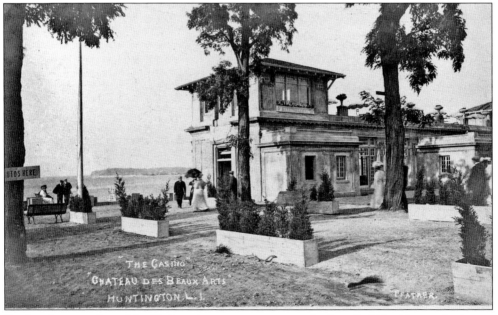

During the operation of the Casino, the guests were put up in the refurbished Locust Lodge on the property, rechristened the Chateau des Beaux Arts. Five of the villas were eventually built and still stand today as homes in the Huntington Bay area. It was not long before the brothers ran into financial and family problems and the property was turned over to creditors. The hotel and casino were eventually razed.

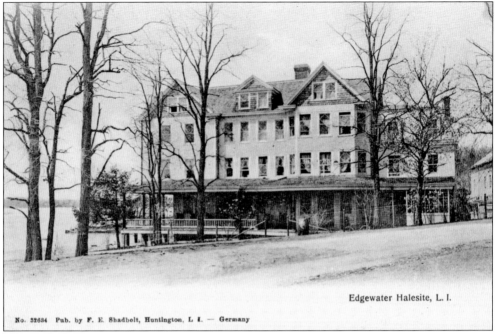

Edgewater Halesite, L. I.

No. 32684 Pub. by F. E. Shadbolt, Huntington, L. I. — Germany

The Edgewater Hotel was built on the old homestead of Capt. Ezra Sammis in Halesite, just at the terminus of the trolley and steamboat lines. The proprietor of the hotel was William R. Selleck, who maintained ownership from its inception in the early 1890s until his death in 1928. It was a popular hotel for long- and short-term boarding (with or without baths) and provided horseback riding, boating, bathing, and fishing. From 1908 to 1911, Juliana Ferguson, heir to her father H. Ogden Armour's fortune, occupied two floors in the hotel to oversee the construction of her nearby monastery-like estate known as Ferguson's Castle. In 1929, the hotel was razed by the new owners to expand the Abrams Shipyard. In the postcard below, the hotel is seen from the nearby town park beach.

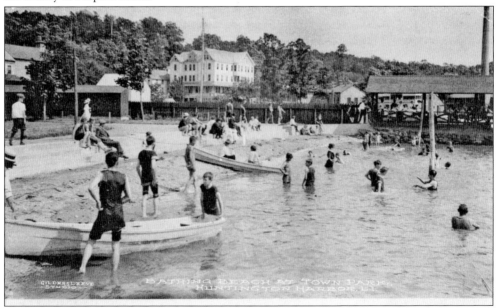

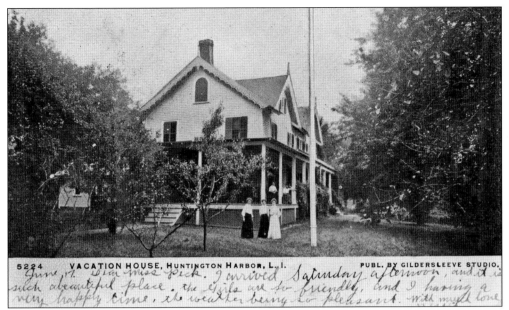

June 1. Dear Miss Peck. I arrived Saturday afternoon, and it is such a beautiful place. The girls are so friendly, and I having a very happy time, the weather being so pleasant. With my love

The Girls' Friendly Society Vacation House was at the east side of the junction of New York Avenue and Mill Dam Road in Halesite. On 15 acres, the property had the sprawling main house, a barn for entertainment, and several other outbuildings. Forty to fifty young women came to this popular location every summer to escape from city life and revel in the country setting.

Huntington was known as a resort area offering fresh air, boating, and fishing. Those who could not afford luxury accommodations might opt for something like this house. This was the Highground Farmhouse near Huntington Bay and the village, which offered first-rate accommodations, farm-raised food, and free bathing. The farmhouse was advertised by the Passiglia brothers.

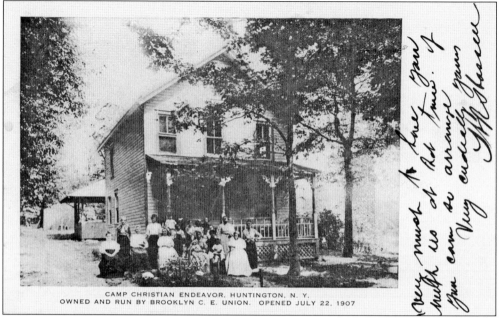

CAMP CHRISTIAN ENDEAVOR, HUNTINGTON, N. Y.
OWNED AND RUN BY BROOKLYN C. E. UNION. OPENED JULY 22, 1907

Camp Christian Endeavor, established by the Brooklyn Christian Endeavor Union, opened in 1907. It provided an opportunity for disadvantaged city boys and girls to enjoy 10 days of recreation, three daily meals, clean surroundings, and fresh air. The postcard above shows original staff members in the first year of operation. The camp was on the north side of Lincoln Avenue, now Broadway, not far from the Huntington train station. In July 1916, a case of polio was discovered in Huntington, and children were temporarily prevented from visiting the camp until it was cleared by the health authorities. The camp operated at the Lincoln Avenue site until about 1926, when encroachment by real estate developers made it less suitable for the children. The property went up for sale that same year.

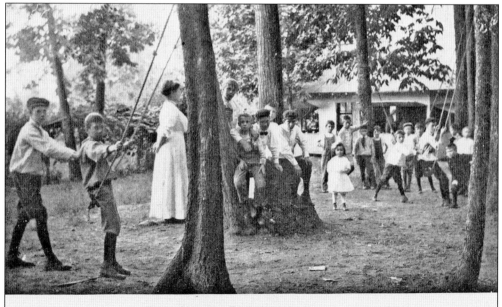

Camp Christian Endeavor, Huntington, L. I.

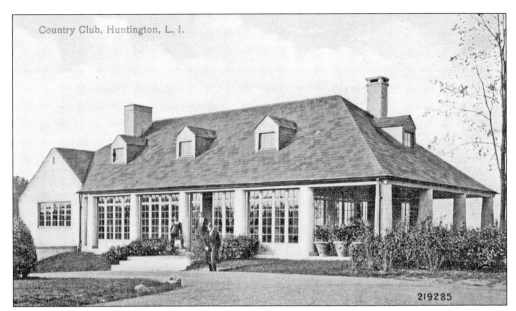

Country Club, Huntington, L. I.

219285

Huntington Country Club is located on 144 acres on prime land between the village and Cold Spring Harbor. It is a private club established in 1910 by a group of wealthy capitalists such as August Heckscher and William J. Matheson. On the property are tennis courts, platform tennis courts, and an 18-hole golf course designed by Devereux Emmet, a pioneer designer during the wooden-shaft club era.

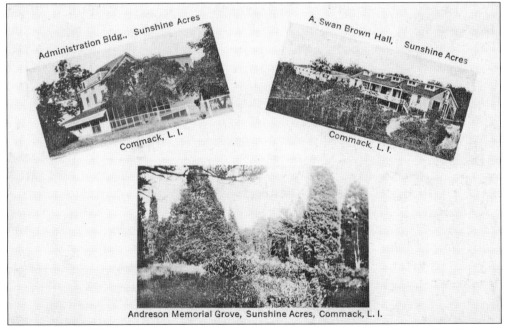

Administration Bldg., Sunshine Acres

Commack, L. I.

A. Swan Brown Hall, Sunshine Acres

Commack, L. I.

Andreson Memorial Grove, Sunshine Acres, Commack, L. I.

The Fresh Air Home, also known as Sunshine Acres, was located on Town Line Road in Commack opposite the Commack Cemetery. It was run by the Young People's Baptist Union of Brooklyn and Long Island. Every summer, hundreds of disadvantaged children of the Baptist churches of Brooklyn and Queens attended the camp for nature studies, hiking, storytelling, and instruction. Acquired by Huntington in the 1960s, it is now Sunshine Acres Park.

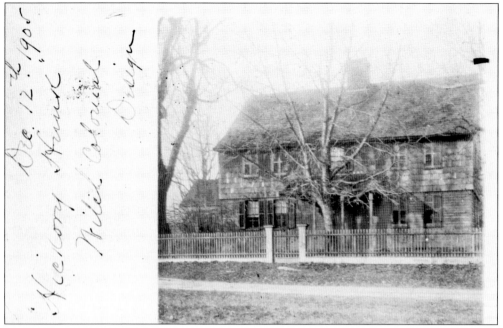

The Ezra Carll Homestead is at 47 Melville Road in South Huntington. The original c. 1700 section was a small one-and-a-half-story structure with a gable roof on the south side of the main house. A two-and-a-half-story hewn-wood-shingled house with a small jetty was added around 1740. It has a massive fireplace in the center of the structure.

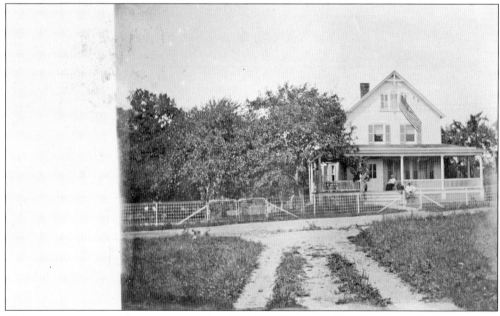

This postcard was sent from the Frederick H. Schild family in Huntington to the Heck family in Half Hollow Hills. References in the *Long-Islander* indicate that the Schilds were visitors of the Hecks on occasion. This house, on Clinton Avenue in Huntington village, still exists. Anna Heck owned three large farm properties on Half Hollow Road at the south end of Carman's Road (now Carman Road).

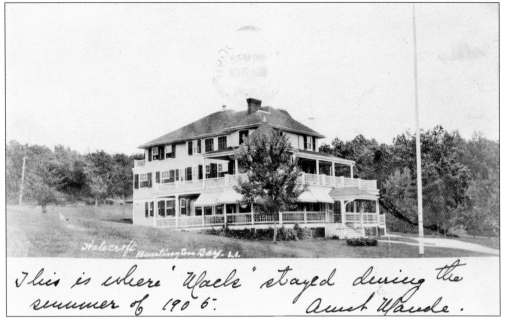

This is where "Uncle" stayed during the summer of 1906.

Aunt Maude.

Halecroft was built in 1900 on George Taylor's 188-acre estate, Halesite, in Huntington Bay. The site was named after the patriot Nathan Hale, who was said to have been captured in that area by the British. The house was often occupied for the summer season by cabinet secretary George B. Cortelyou and his family. Taylor's permanent place in Huntington history involved a large boulder, a glacier castoff, that he had moved to his property. Three bronze plaques were affixed to the rock with inscriptions of dubious accuracy regarding the life of Nathan Hale. In 1974, Taylor's grandson had the 45-ton boulder, subject to vandalism and damaged by a 1944 hurricane, moved by the Huntington Public Works Department to the intersection of Mill Dam Road and New York Avenue, where it remains today.

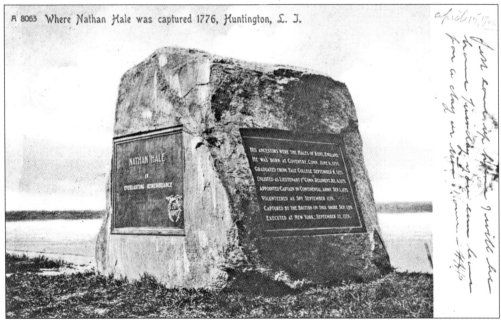

A 8063 Where Nathan Hale was captured 1776, Huntington, L. I.

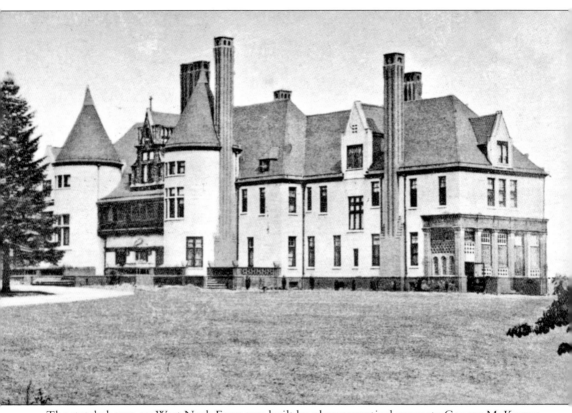

The stately home on West Neck Farm was built by pharmaceutical magnate George McKesson Brown as a country estate for him and his wife, Pearl. The chateau-style mansion was designed by architect Clarence Luce. The house had electric lights, forced ventilation, and other innovative conveniences for 1911. Brown was a gentleman farmer who raised chickens, even to the point of studying scholarly articles on how to breed the most prolific egg layers. The onset of the Depression put an end to the lavish lifestyle and the farming. By 1939, the Browns had moved into a cottage on the property and sold the main house to the Brothers of the Sacred Heart, who rechristened it Coindre Hall after the founder of their community. In 1962, the Unitarian Universalist Fellowship purchased four acres of the estate, which included the cottage, a garage with chauffeur quarters, and a 70-foot water tower that, in disrepair, had to be dismantled brick by brick when a wrecking ball failed to penetrate its thick walls. This Gold Coast mansion survives to this day.

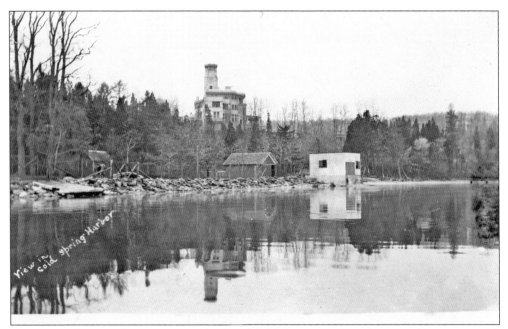

Located on the west (Nassau County) side of Cold Spring Harbor, this sprawling estate with an 84-room main house was designed and built by Louis Comfort Tiffany. It was completed in 1905. After Tiffany's death, the property was eventually subdivided, and in 1957, a fire gutted the abandoned house. All that remains are stone fences and a power smokestack. This postcard shows Laurelton Hall from an unusual water vantage.

This house on Shore Road in Cold Spring Harbor was used as a summer cottage by the family of Henry G. DeForest, whose main estate was just north along the same road. A portion of the house dates to before the Revolutionary War. It was owned by George Mowbray prior to the purchase of the house and over 100 acres by DeForest. Both homes still stand today.

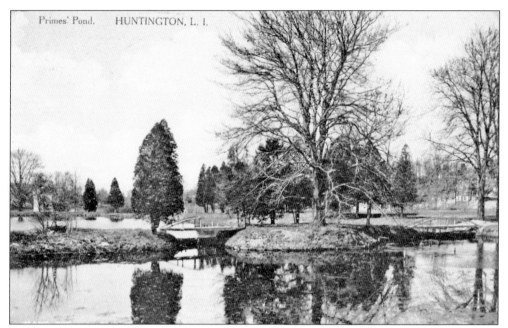

Lake Heckscher has had various names in the past, such as Crystal Lake and, most notably, Prime's Pond. According to a December 22, 1865, *Long-Islander* article, Ezra Prime, the property owner, constructed his pond for ice and for skating. In 1894 alone, he harvested 150 tons of ice from the freshwater pond for the village. In early January, he would allow villagers to skate on the uncut sections.

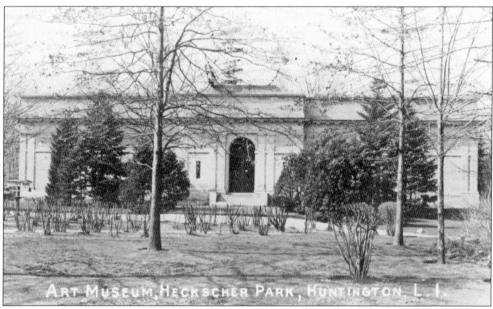

After Ezra Prime, August Heckscher owned the land and cleaned up the rundown area. The Heckscher Art Museum was built by Heckscher and opened in 1920. He gifted many paintings from his own collection to the museum. In 1954, the Town of Huntington took ownership of the museum. Operating as a nonprofit corporation today, the little museum, with its permanent and special collections, is a highlight of Heckscher Park.

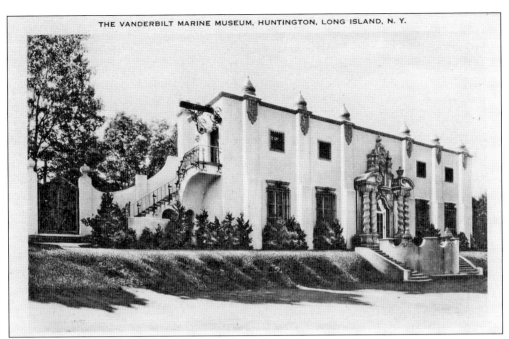

William K. Vanderbilt II built his Eagle's Nest estate on the east side of Centerport overlooking Northport Harbor. Vanderbilt was an avid collector of marine and bird life, which he gathered from around the globe aboard his yacht *Alva*. He built the marine museum to house his private collection, which was the largest in his day. The museum opened to the public in 1922 and is still in operation.

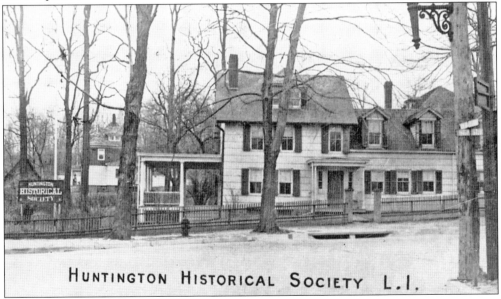

Many historical societies start with a collection of artifacts and some passionate volunteers who understand the need to preserve local history. In 1904, the Colonial Society was born; it turned into the Huntington Historical Society in 1911. That same year, it moved into the David Conklin house (pictured). In 1982, the society purchased the Sewing and Trade School on Main Street, where the archives and offices are currently located.

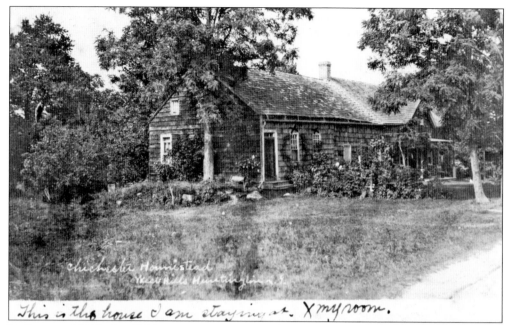

Built around 1680, the Chichester Inn, or Peace and Plenty Inn, was an early inn and tavern in West Hills frequented by travelers along the north-south route through the township. The main room of the house had an unusual hinged room divider that could be removed to accommodate town meetings. The recipient of this postcard, Agnes Shipman, lived in Greenport and was a teacher at Baiting Hollow School.

The summer home of Willard N. Baylis was in Bay Crest along Huntington Harbor. Baylis was born in Huntington and graduated from Huntington High School in 1879. He became a prominent attorney in Huntington and New York and was also known for his philanthropy. In 1913, Booker T. Washington wrote Baylis to request a loan on his Northport property in order to finance investments near Tuskegee, Alabama.

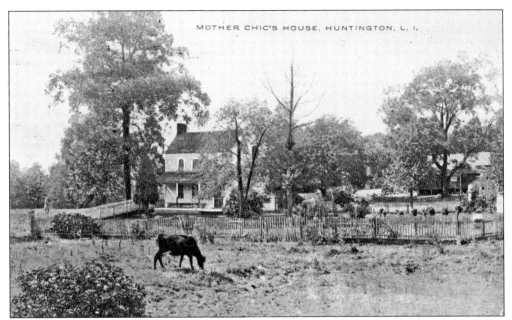

Mother Chic's Tavern, dating from the mid-1700s, was owned by widow Rachel Chichester and located on Bay Road in Huntington Bay. Historians believe that the tavern was a meeting place for British sympathizers. Possibly apocryphally, it is said that Nathan Hale was betrayed by his cousin John Strong Hale at the tavern, which led to his capture and execution by the British.

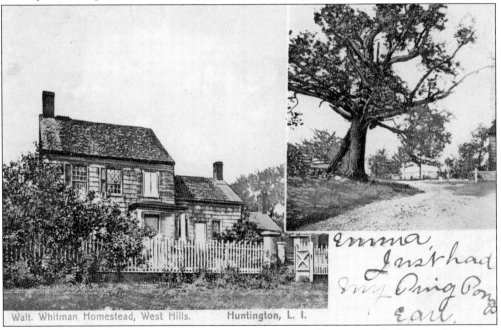

Walt. Whitman Homestead, West Hills. Huntington, L. I.

Walt Whitman was born in this family farmhouse in West Hills in 1819. The house, which exists today, is one of many historic stops in Huntington. When he was four years old, Whitman's family moved to Brooklyn, but he returned to teach when his family moved to Hempstead. In 1838, Whitman returned to Huntington and founded its local paper, the *Long-Islander*, which is still in print today.

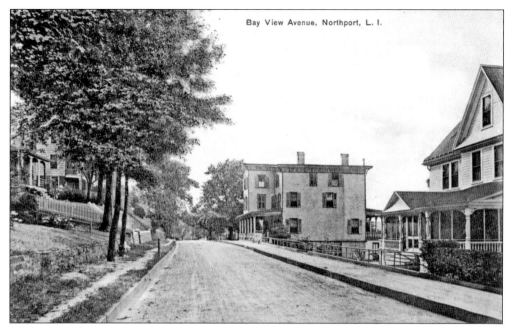

Looking south on Bayview Avenue, the Henry Ackerly House (center) and Stanley Lowndes House (right) are shown in this 1910 postcard. The Ackerly House was built around 1868 and was principally used as a boardinghouse. It was quite popular for its waterfront activities, such as boating and clambakes. It was torn down in 1939. The house of Stanley Lowndes, an oyster baron, still stands.

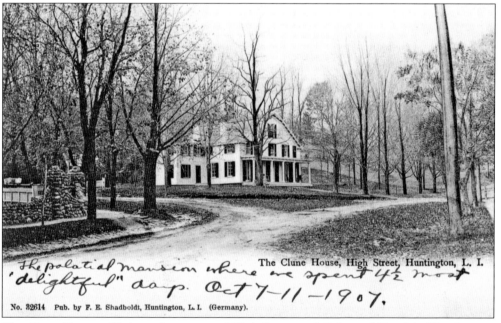

The palatial mansion where we spent 4½ most 'delightful' days. Oct 7–11–1907.

The Clune House, High Street, Huntington, L. I.

No. 32614 Pub. by F. E. Shadboldt, Huntington, L. I. (Germany).

The Clune House still sits at the corner of High Street and Oakwood Road in Huntington. With the exception of some added skylights and a west wing, it looks relatively the same. The boardinghouse, purchased in 1906 by Elecia Clune from William Woodhull Sammis, was used for long- and short-term leases. At one time, a barn on the property was also available for lease.

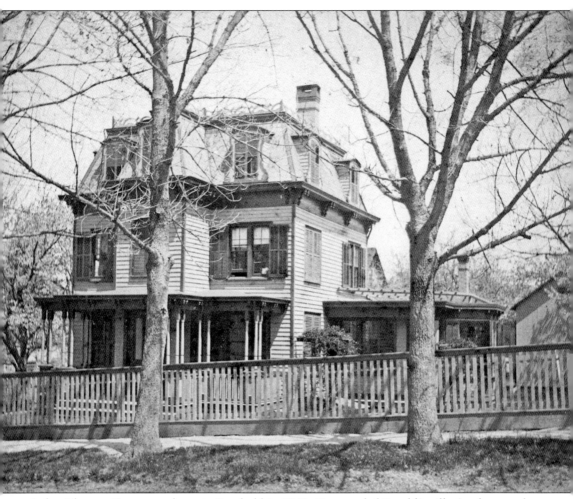

Judge Thomas Young was born in Southold in 1840. He attended Franklinville Academy and entered Yale at the age of 19. On March 6, 1860, while attending Yale, he had the opportunity to listen to Abraham Lincoln deliver an impassioned speech against slavery. Young graduated in 1863 and immediately enlisted for service. He was commissioned a lieutenant in the 8th Regiment, US Colored Troops, and was a major by the time his service ended. In 1866, Young established an office on the Brush Block of Main Street, Huntington, to begin his career as a lawyer. He was a director of the Huntington Bank (his office was directly above) and the Huntington Water Company. He was also president of the Soldiers' and Sailors' Memorial Association and was highly esteemed in all of his endeavors. He died in Brentwood in 1918 when he was struck by a train. Young owned property along Oakwood Road from the Huntington Rural Cemetery to High Street. His stately home, Oakwood, no longer exists. In 1923, the new development of Knollwood cut through the former property.

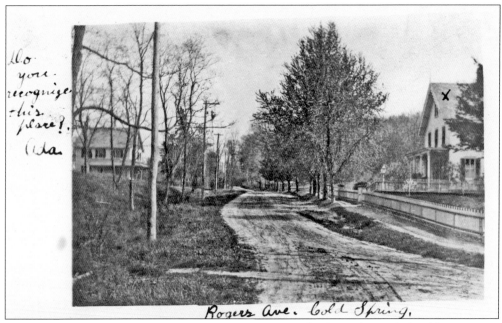

Rogers Ave. Cold Spring.

Thanks to the sender's additions, this postcard is known to show Rogers Avenue in Cold Spring Harbor. Today, the road is called Turkey Lane. The most prominent house on this road in 1906 was the summer residence of Caroline C.L. Barton, seen on the right. Barton (c. 1850–1919) was the widow of Dr. Thomas Maitland.

The 1884 Victorian Davenport House sits at the entrance to the Cold Spring Harbor Laboratory. When the house was built, the property belonged to John D. Jones, who later donated the building and property to the laboratory. The house was originally used by Frederic Mather, the first director of the fish hatchery. In 1898, Charles Davenport became the director of the laboratory, and the house was later named in his honor.

Three

BUSINESSES AND SERVICES

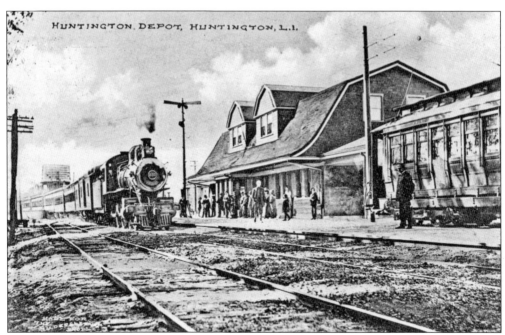

Before 1868, north shore trains from New York terminated at Syosset. Passengers had to disembark and take stages to Oyster Bay, Cold Spring Harbor, and Huntington. The sender of this March 15, 1910, postcard writes, "[The] Huntington Opera house was burned down to the ground last night. It was a big fire."

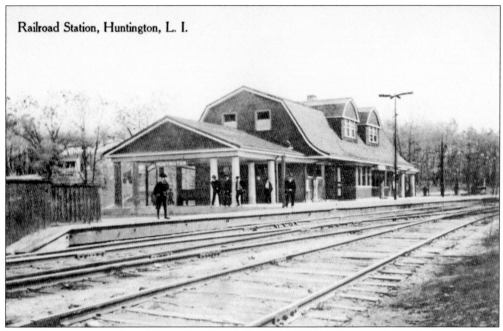

Railroad Station, Huntington, L. I.

The original train depot in Huntington Station (then called Fairground) opened on January 13, 1868, and was located on the south side of the tracks. In 1909–1910, when the New York Avenue grade crossing was eliminated in favor of an overpass, a new station house was built on the north side. It is still in use.

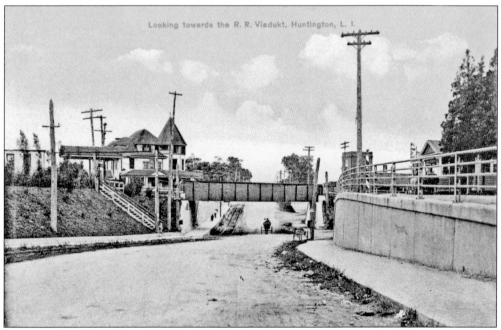

Looking towards the R. R. Viadukt, Huntington, L. I.

This postcard shows the New York Avenue train overpass at the Huntington railroad station looking south. The low spot in the road under the overpass was subject to frequent flooding during heavy rains, and as a result, automobiles occasionally got stuck in the deep water. Gerlick's Hotel can be seen on the left, and the trolley tracks that ran from Amityville to Halesite are evident.

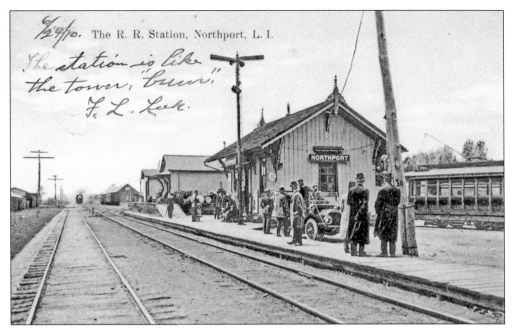

The Northport railroad station, located in East Northport, opened in 1873. There used to be a rail spur to Northport village, but it was replaced by the trolley line, whose tracks are still evident in the village in order to maintain the history of the area. East Northport is actually south of Northport, but east of the junction that used to link up to the village, hence its name.

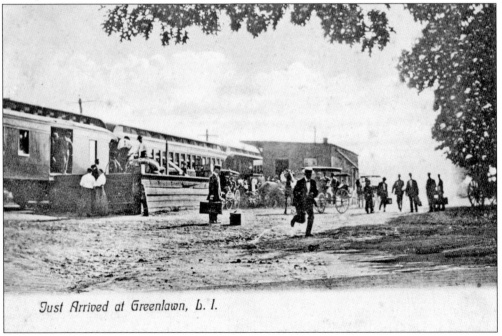

Both the Greenlawn train depot and the Huntington depot to its west opened in 1868. Greenlawn, then called Old Fields, went through three name changes starting with Centerport, Greenlawn-Centerport, and finally Greenlawn in 1870. The first station house burned down in 1910, and in 1911, a small station was built that is still in service today.

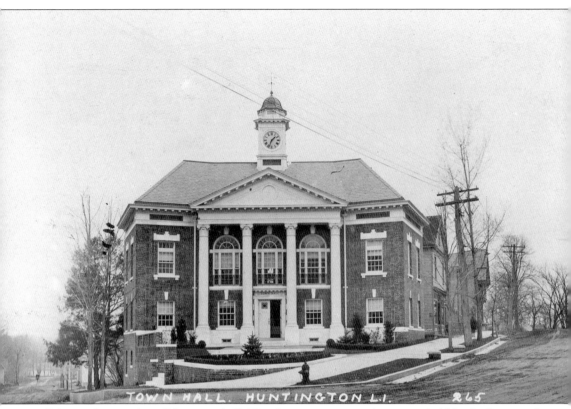

TOWN HALL. HUNTINGTON L.I. 265

Prior to the erection of the town hall, Huntington town meetings were held in the Peace and Plenty Inn, Platt's Tavern, churches, homes, the Euterpean Hall on Main Street, and any other convenient location. As the town grew, it was necessary to find a single location for town meetings, governance, and tax collection. The contract for the construction of an official town hall was awarded to a local company, Wanser & Lewis, with a bid of $15,966.93. The architects were from Peabody & Wilson. The cornerstone was laid on March 7, 1910, with a copper box containing coins and a number of paper items indicative of the current date and history of the town. The building opened for business in October 1910. The first office that opened was that of the receiver of taxes, Charles E. Sammis.

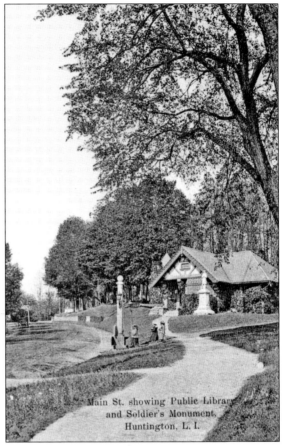

Main St. showing Public Library and Soldier's Monument, Huntington, L. I.

It is relatively easy to date photographs of the Memorial Library. The earliest images have the flagpole to the left, no ivy, and no plaque on the Nathan Hale Monument. The cannon, donated by the US government, arrived by boat for the 250th anniversary of Huntington in 1903. The cannon replaced the flagpole, which was moved to the west side of the building. The column in the foreground along the road is the Nathan Hale Monument and plaque. There was a water fountain in the back and a water trough for horses in the front. Today, the building is used as a museum and office for local history. The sender of the postcard below wrote that he took and printed this picture of the library.

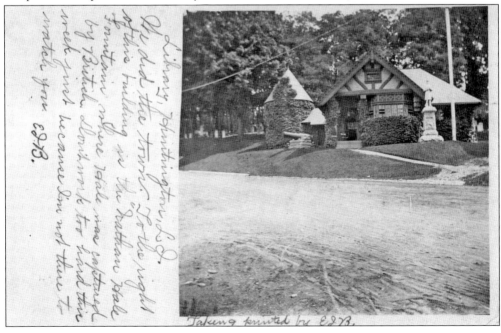

Taken & printed by E.J.B.

49

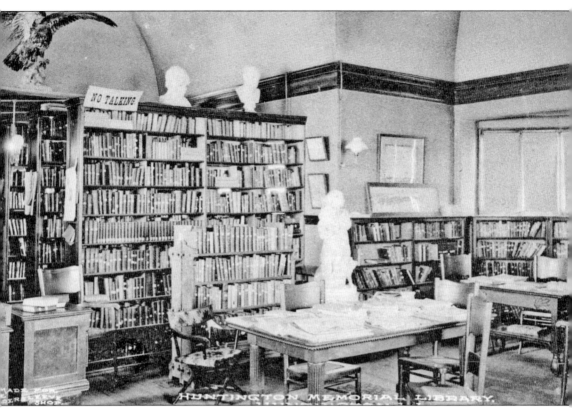

Huntington has had a library in some form or another since before the Revolutionary War. After the Civil War, the Huntington Library Association was formed to help raise money to acquire books and search for a suitable location for a new library. The titles of the purchased and donated books were often announced in the *Long-Islander*. In 1888, the library, with nearly 3,000 volumes and a host of periodicals, needed a proper facility to house the growing collection and provide a comfortable reading area for patrons. The Soldiers' and Sailors' Memorial Building was completed in 1892. It was erected to honor the many Huntingtonians who died during the Civil War. The oft-used firm of Cady, Berg, and See designed the building, which also functioned as Huntington's new library. In 1958, the Huntington Library moved to its current location in the old telephone company building at the corner of Main and Prospect Streets. As can be seen in this postcard, the familiar request for silence in the library is not a modern observance.

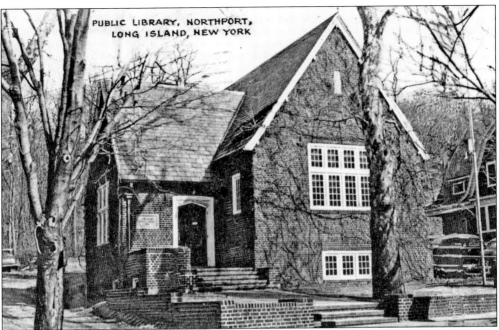

PUBLIC LIBRARY, NORTHPORT, LONG ISLAND, NEW YORK

On the stormy night of December 13, 1915, the $10,000 Carnegie-financed library building had its formal opening as the Northport Public Library. The visitors that evening were entertained with speeches and performances by the Northport Orchestra. A new library was constructed on Laurel Avenue in 1966. The Carnegie building, at 215 Main Street, is now the home of the Northport Historical Society and Museum.

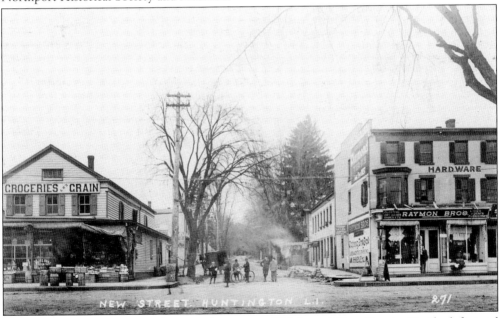

In 1910, there were two merchants at the corner of Main and New Streets. On the left stood G.W. Smith's Groceries and Grain, where one could get Hotel Astor coffee for 35¢ a pound and Fig Newtons for 12¢ a pound. On the right were the merchants Isidor and Samuel Raymon, who sold dry goods and clothing for over 30 years at that same location.

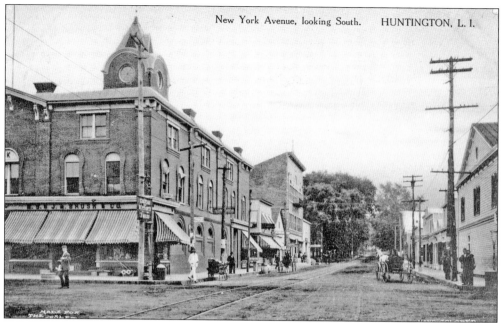

The Brush family settled in Huntington when Thomas Brush arrived in the 1650s. There has been a long list of patriots, farmers, businessmen, and civic-minded Brushes. Henry S. Brush and James M. Brush constructed the brick building above in 1889 after the big fire of 1888, which destroyed many of the wood-frame structures on the block. Their general merchandise business, as well as other displaced businesses such as E.C. Grumman's stationery store and a dental office, continued in the new building. The new Brush Block even had a rifle range. Above, following south down New York Avenue, is the Masonic temple (which still stands), the post office, and the Unitarian church. To the east in the Brush Building (below) was the Bank of Huntington and G.F. Barr's jewelry store.

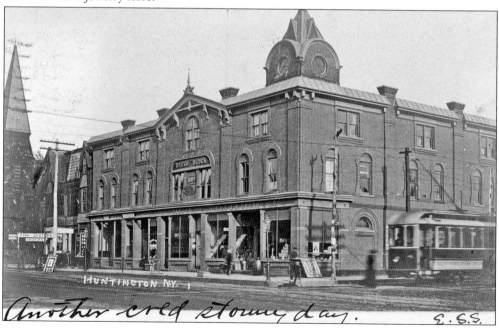

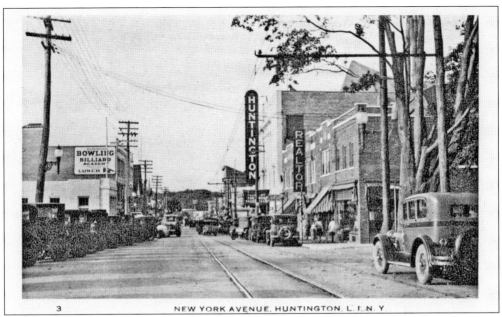

This view of New York Avenue in Huntington is from West Carver Street looking north. On the right is the Huntington Theater, which opened on May 5, 1927, with the film *The Better 'Ole* and some vaudeville acts. In the 1970s, the interior was redesigned and the theater rechristened the Balcony Theater. Remodeled again in the 2010s, the newly christened Paramount, allowing multiple floor plans, opened on September 30, 2011.

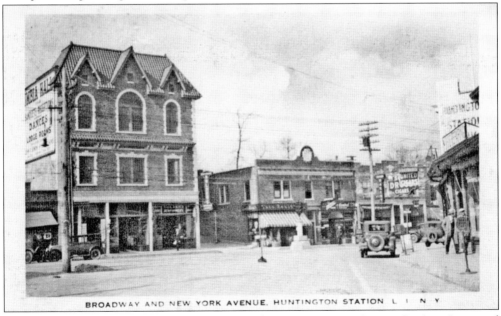

Columbia Hall was at Broadway and New York Avenue in Huntington Station. It catered wedding receptions and offered space for meetings and rental rooms for commerce. Various small businesses occupied the street level, including John Hulsen's Stationery Store at the bottom right, whose sign hangs from the right side of the building. Urban renewal eventually caught up, and the entire block was razed.

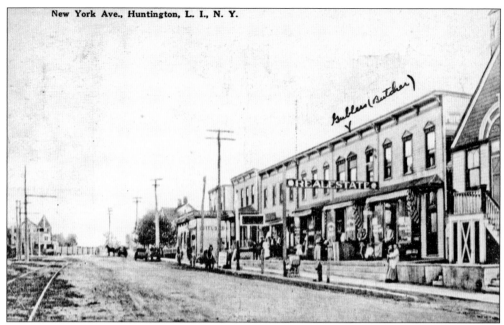

This is New York Avenue looking south to the Huntington train station. Gerlick's Hotel can be seen on the left. The postcard was mailed in 1919, and the sender identified one of the businesses as Gubler's. Fred G. Gubler owned a delicatessen and butcher business at this site. Upon his retirement in 1932, he sold it to William Geinsheimer.

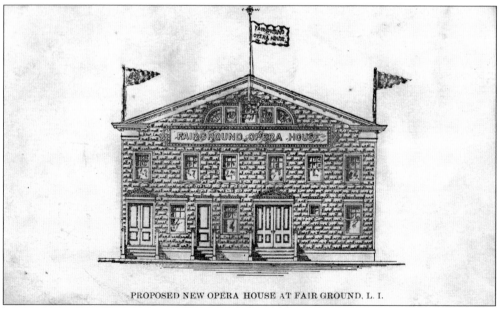

PROPOSED NEW OPERA HOUSE AT FAIR GROUND, L. I.

This 1910 postcard shows the first opera house/theater located in Huntington Station, which was then called Fairground. The theater was built a short distance south of the railroad station and opened on February 21, 1911. With the growing popularity of films, the interior was remodeled, and on April 13, 1914, the theater was reopened and rechristened the Orpheum Theatre. It was managed by Hughie Flaherty.

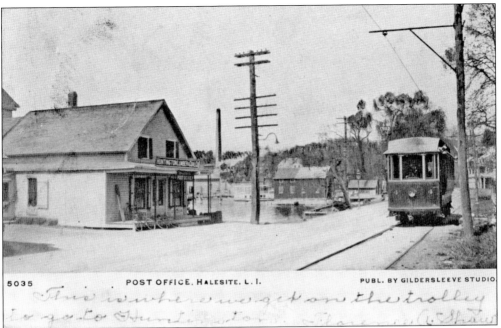

In the summer of 1899, builders Merrill and Strickland erected an addition to the Huntington Lumber and Coal Company specifically for the Halesite Post Office. In the early 1900s, there was confusion with three operating post offices within a small area: Halesite, Huntington, and Fairground. Letters, bills, and invitations were often late arriving because they were routed to the wrong office.

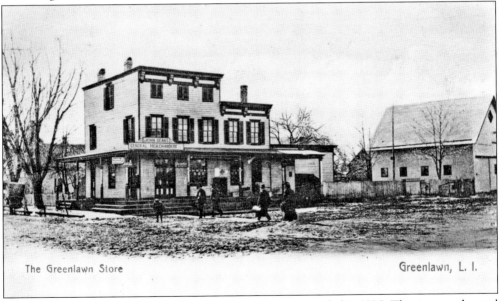

The Greenlawn Store Greenlawn, L. I.

This well-known c. 1899 image of the Greenlawn store was mailed in 1908. The store was located near the Greenlawn train depot. At the time of this image, the building was expanded by the new owner, John Dean. It still stands today with some structural modifications. Greenlawn's first post office was located in this store, and Hezekiah Howarth, who owned the store, was Greenlawn's first postmaster.

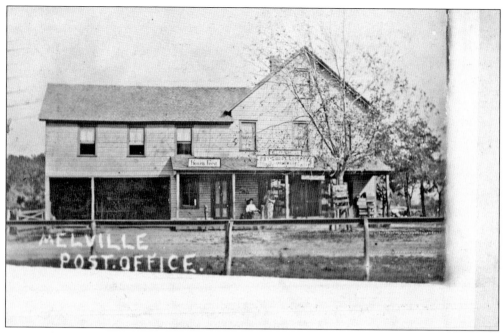

A post office in Melville was established in November 1897 at the Melville railroad station on the main line. Although the train station was called Lower Melville, the post office was called Pine Lawn. The first postmaster was B.A. Merritt. In August 1898, the name was changed to the Melville Post Office.

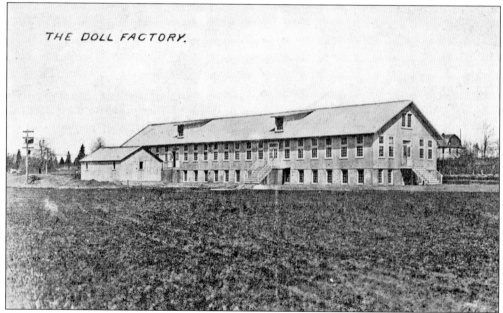

Often referred to as the "Doll Factory," the Northport Novelty Company, on the corner of Third Street and Tenth Avenue, assembled and painted dolls. It opened in 1911 and closed for business in 1915. During World War I, the building was used to manufacture surveillance balloons. After that, several different businesses occupied the building until it was torn down in 1960 for railroad commuter parking.

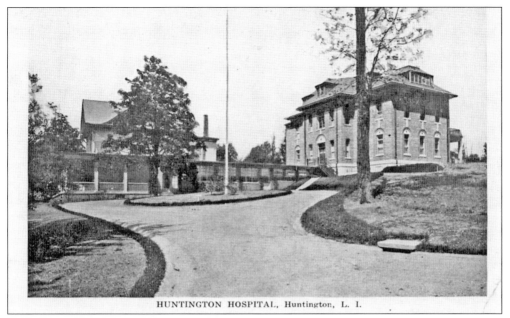

HUNTINGTON HOSPITAL, Huntington, L. I.

Prior to the erection of Huntington Hospital, the sick and injured were treated at the Winkworth Cottage Hospital on New Street. In 1915, Cornelia Prime purchased property on Park Avenue for the purpose of building the new hospital and financed the construction of the nurses' home. The hospital received its first patients in 1916. The building to the right still exists with a large extension built in 1931 behind it.

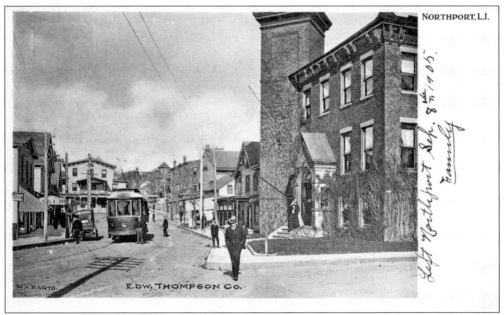

NORTHPORT, L.I.

EDW. THOMPSON Co.

The importance of Edward Thompson's presence in Northport cannot be overemphasized. He arrived in 1882 and cofounded the Edward Thompson Company, publisher of law books. The economy of Northport grew with the influx of lawyers and professionals to the area. In 1886, Thompson had his first house built at 63 Bayview Avenue, which still stands. His publishing house building still graces the corner of Woodbine and Scudder Avenues.

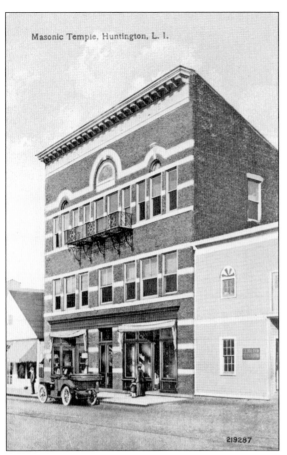

Masonic Temple, Huntington, L. I.

219287

The committee for the new Masonic temple, to be located on New York Avenue near Main Street, had the goal to start construction on April 1, 1904, but delayed until the price of bricks came down. In August 1904, the schooner *Messenger* arrived at Archer's Dock laden with H&F bricks to start construction. The letters "Masonic Temple" and the cornice work at the top were completed in December 1904.

Established by James M. Brush, Henry S. Brush, and Douglass Conklin, the Bank of Huntington began operations in 1885. The first bank was destroyed in the 1888 fire. It moved into an office in the new Brush Block until the bank in this postcard was built in 1916 next to the Central Presbyterian Church, where it still stands. By 1922, the bank was considerably healthy, with resources over $3.4 million.

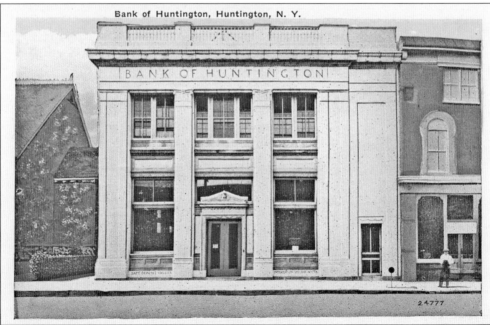

Bank of Huntington, Huntington, N. Y.

24777

The Northport Fire Department was established in 1889 and reorganized as an incorporated village fire department in 1896. This new truck building was erected in 1905 on the south side of Main Street, approximately where the current fire department building stands. The "fire laddies" of Northport moved into this building on March 22, 1906.

This frame firehouse building in Commack opened in April 1908 on a lot on the north side of Jericho Turnpike not far from where the current Commack firehouse sits. The Commack Hook and Ladder Company No. 1 was chartered by the state department with directors Frederick E. Haddon, John Moreland, William Mahler, Frederick Goldsmith, and Oliver D. Burtis. Haddon owned property directly next door.

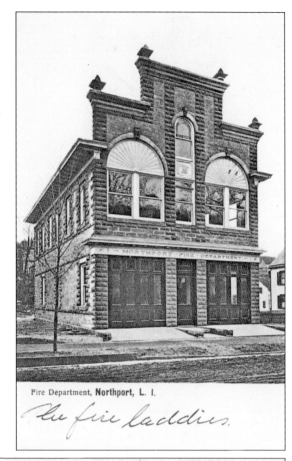

Fire Department, **Northport**, L. I.

The fire laddies.

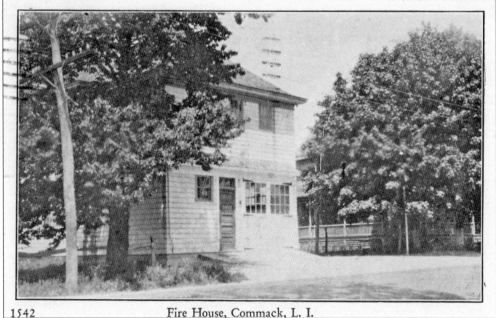

1542 Fire House, Commack, L. I.

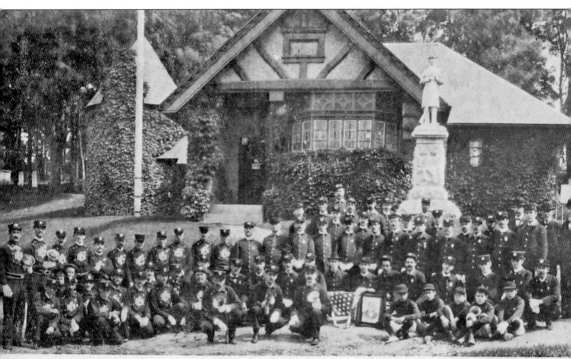

849 HUNTINGTON FIRE DEP'T & LIBRARY PUBL BY GILDERSLEEVE STUD

There are various dates given for the creation of a fire company in Huntington. Certainly a group of volunteers and even the home and shop owners would have participated in fighting fires with the available methods of the time, using hand- or horse-pulled wagons with hooks, ladders, buckets, and hand pumps to control the fires that inevitably cropped up due to carelessness, arson, and natural events. In 1844, a state law was passed that permitted town boards to appoint inhabitants to a fire company as needed. The threat of a large fire was ever present given that the frame homes and shops that lined the village streets were made of combustible materials. In a December 29, 1843, *Long-Islander* column, the editors implored the householders and shopkeepers to be careful, as Huntington was "sadly destitute of the means of extinguishing fires," and one false step could reduce "a large portion of our beautiful village to a pile of ruin." In fact, in 1888, nearly the entire block west of the Old Burying Ground was destroyed by fire.

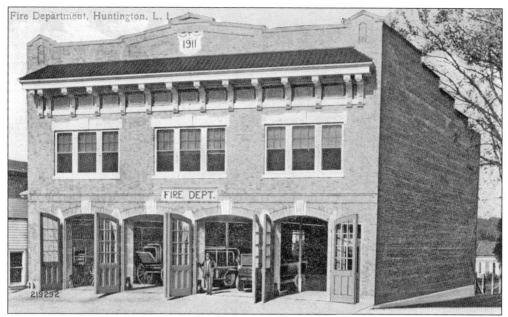

The first official Huntington firehouse was built on Wall Street in 1869 and consisted of a white clapboard building with one engine bay and a lot. By 1911, four new sites were considered for a larger firehouse. The selected location was a site owned by W.N. Baylis on Main Street. The new Huntington Fire Department building was completed in late August 1912 at a cost of $13,000. Furniture and fire apparatus were moved to the facility in early August, before completion. Even though the date of 1911 has been added by hand near the top of the building's facade, the firehouse did not open in that year. The new firehouse was dedicated on September 12, 1912. The structure still exists today but is repurposed for use by a furniture store. The truck bays are gone, but the facade is intact.

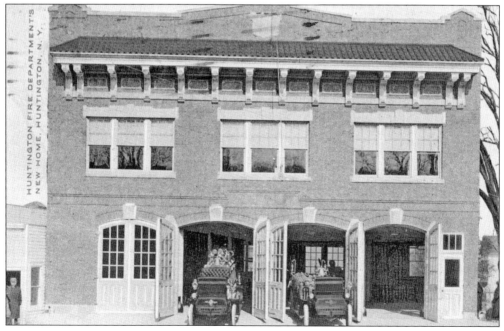

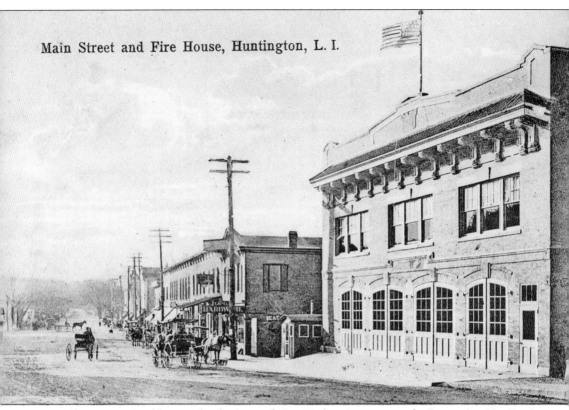

Main Street and Fire House, Huntington, L. I.

Led by Fayette Gould, an act by the State of New York to incorporate the Protection Fire Engine Company No. 1 in Huntington was passed on April 2, 1862. Gould may have had ulterior motives. He was not pleased to be pulled away from his jewelry and photography businesses on many occasions to serve on a jury, and as it is written in the act, firemen would be exempt from jury duty. In 1878, the *Long-Islander* called the one fire engine owned by the department "almost wholly useless" and reported that the department would still be relying on hooks, ladders, and buckets to fight fires. In 1879, a local man, Ebenezer C. Lefferts, constructed a series of ever-improving chemical fire engines that may have started a revival of interest in the Huntington Fire Department. The department took serious steps to repair its equipment and purchase new apparatus, and added a number of good men to its ranks. The efforts of the fire laddies to improve their services prevailed, and today Huntington can be proud of its fire departments.

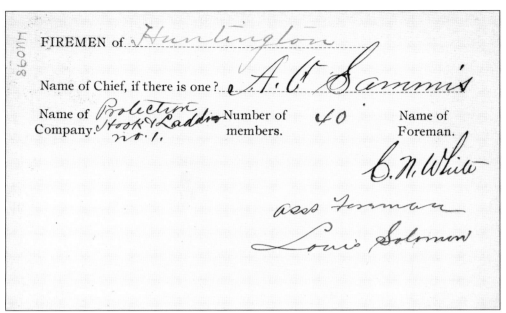

FIREMEN of *Huntington*

Name of Chief, if there is one? *A. V. Sammis*

Name of Company. *Protection Hook & Ladder no. 1.* Number of members. *40* Name of Foreman. *C. N. White*

ass Foreman

Louis Solomon

This 1905 postcard tells a great deal about the fire department at that time: the chief's name (Albert V. Sammis), the name of the company (Protection Hook and Ladder No. 1), how many members (40), the foreman (Charles N. White), and the assistant foreman (Louis Solomon). The card was mailed to Suffolk County historian Richard M. Bayles.

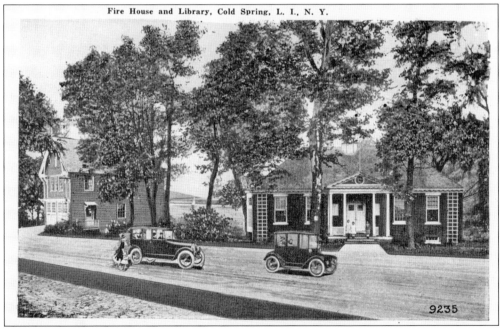

Fire House and Library, Cold Spring, L. I., N. Y.

9235

When a new firehouse was needed in Cold Spring Harbor, the 1906 building, once on Main Street, was auctioned off. The Cold Spring Harbor Laboratory bought it for $50, hoisted it onto a barge, and floated it across the harbor to the laboratory, where it now stands as a residence for scientists. The library building, constructed in 1913, remains today, but the library has moved.

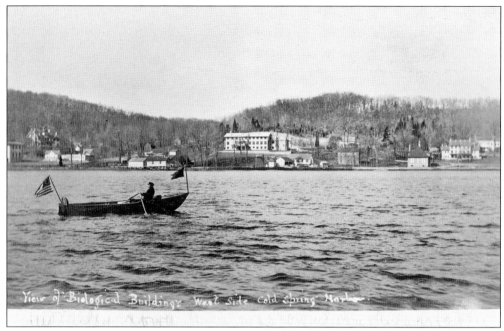

The current Cold Spring Harbor Laboratory has several buildings in Huntington Township, although the main campus is in Nassau County on the west side of the harbor. In this 1909 postcard photograph, taken looking west across the harbor, the Carnegie Building and the Davenport House are to the far left, Blackford Hall is prominent at center, and the Jones Laboratory and Hooper House are to the right.

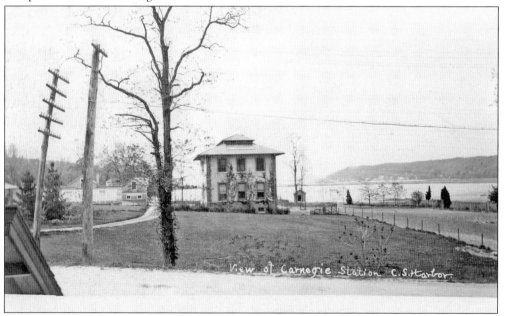

Today, with mature trees and shrubbery, this beautiful view of the Carnegie Building and Cold Spring Harbor is not visible from the postcard's vantage point. A number of small outbuildings pepper the laboratory grounds, many of which were already part of the Jones property that the laboratory stands on.

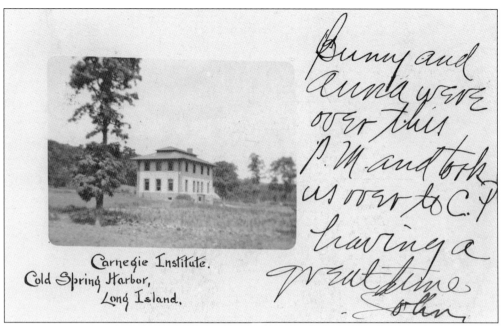

Carnegie Institute.
Cold Spring Harbor,
Long Island.

Bunny and Anna were over this P.M. and took us over to C.J. having a great time. — John

Charles Davenport, director of the Biological Laboratory, encouraged the Carnegie Institute of Washington to support a year-round center to study genetics. On additional land leased from John D. Jones, the Station for Experimental Evolution at Cold Spring Harbor was established in 1904 with Davenport at the helm. The first research laboratory built under the Carnegie Institute was the brick and stucco Carnegie Building (1905), which the writer of the postcard below called the "Bug House." The study of insects, aquatic animals, and birds was indeed done in that building. Davenport was deeply involved in the eugenics movement and Mendelian genetics and opened the Eugenics Record Office in 1910 to further that research. The fascinating records of that office (which closed in 1940) and the Biological Laboratory are housed in the archives of the Carnegie Building, now the Carnegie Library.

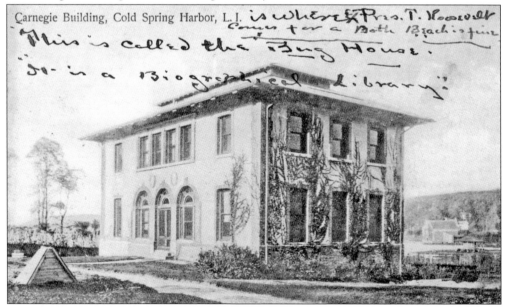

Carnegie Building, Cold Spring Harbor, L.I. is where ex-Pres. T. Roosevelt comes for a Both Brachiofine. "This is called the "Bug House." So is a Biographical Library."

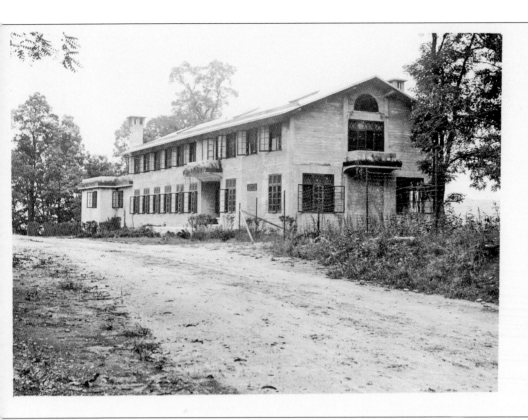

Eugene G. Blackford was a fish merchant in his early days and built up a substantial company in that business. He eventually was appointed as a fish commissioner. Blackford convinced Franklin Hooper, the first director of the Brooklyn Institute of Arts and Sciences, that Cold Spring Harbor was an ideal location for a biological laboratory. On land donated by John D. Jones, the Biological Laboratory, under the auspices of the Brooklyn Institute, was founded in 1890. Blackford was part of the laboratory's board of managers from its inception until his death in 1905. Blackford Hall was built using generous funds donated by his widow. The memorial building was dedicated on June 1, 1907. It was originally used as a dining hall and dormitory; today, it functions principally as a dining facility. It was the idea of William J. Matheson, Blackford's successor, to build using poured, reinforced concrete, a new construction technique at the time.

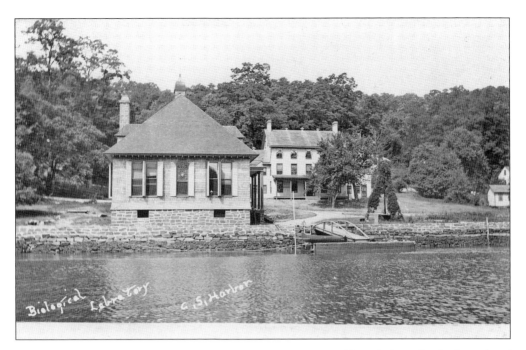

In 1893, the Biological Laboratory opened a new laboratory building dedicated to biological and bacteriological study for advanced students. The Jones Laboratory, named after John D. Jones, who contributed $5,000 for the building as well as the property, had tables for class instruction and research, and fresh and saltwater aquaria. Close to the harbor shore, small boats could be launched on the water to collect specimens for the aquaria. The Hooper House (above, background) was built in 1835 and leased to the laboratory as a men's dorm. A whaling kettle, in which whale blubber would have been boiled into oil, can be seen by the shore.

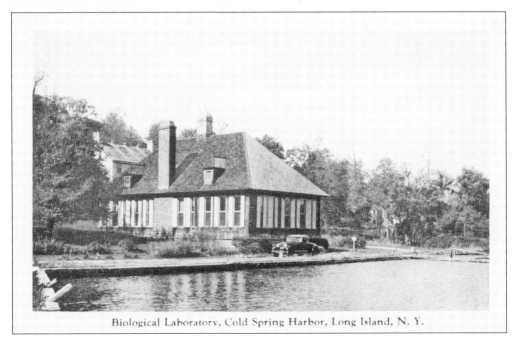

Biological Laboratory, Cold Spring Harbor, Long Island, N. Y.

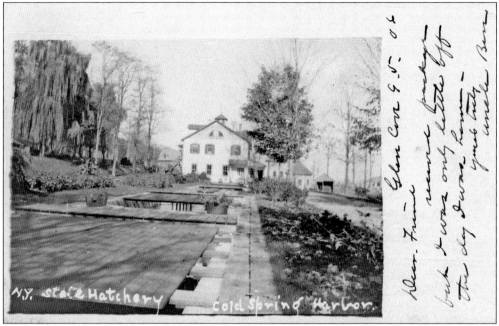

N.Y. State Hatchery Cold Spring Harbor.

Eugene G. Blackford established the New York State Fish Hatchery in Cold Spring Harbor in 1882. Jonathan Mason of the Caledonia Hatchery was in charge of fitting the new hatchery with similar appliances to Caledonia and even provided the initial spawn. The hatchery formally opened on March 14, 1883. By June, over 120,000 salmon and trout were shipped from the hatchery to the Adirondacks. By September 1884, Frederic Mather, a pisciculturist and superintendent at the hatchery, announced that over 1.6 million fish were supplied by the hatchery and planted throughout New York State. In 1887, a new building was erected to replace an old woolen mill that was being used on the Jones property. As of March 1982, the hatchery was operating as a nonprofit educational center.

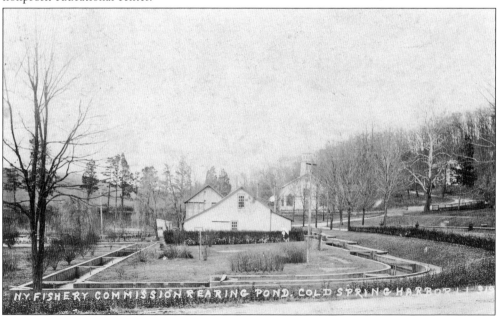

N.Y. FISHERY COMMISSION REARING POND. COLD SPRING HARBOR L.I.

Four

HOSPITALITY

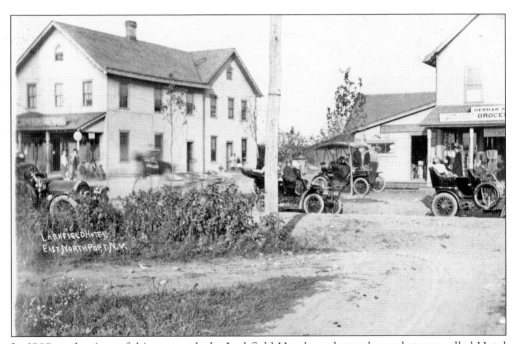

In 1909, at the time of this postcard, the Larkfield Hotel was located on what was called Hotel Row in East Northport. Leighton's Hotel was on the north side of the railroad tracks, and Larkfield Hotel was on the south. The hotel has been known under various names, such as Larkfield Inn, Mortensen's Hotel, and Powell's Hotel. On holidays, it was a popular spot for refreshments after entertainment and parades.

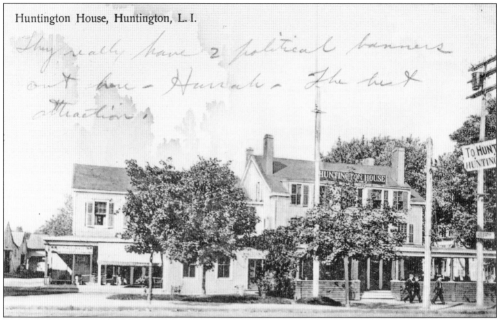

Huntington House, Huntington, L. I.

They really have 2 political banners out here — Hurrah — The best attraction

The Huntington House occupied the large lot at the northwest corner of Main and Wall Streets. Established in 1816, the house was the main social meeting place in the village. With stables in the back, early visitors would board their horses while imbibing in the barrooms within. Frequently, civic, political, and social groups would meet there. Outside the building, speeches were held and auctions conducted. It had rooms for short- and long-term stays, a barber, a small police office, and a table d'hôte restaurant. In 1898, the building was expanded to include a large billiard room where betting on matches was legal. During holiday and firemen tournament parades, grandstands were erected on the Main Street side for dignitaries and judges. Prohibition closed the doors of Huntington House, which was sold and subsequently razed in the early 1920s.

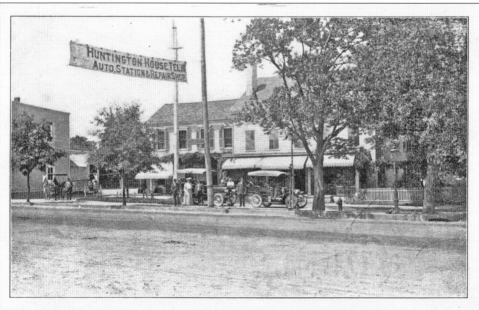

THE HUNTINGTON HOUSE. PUBLISHED BY D. W. TRAINER, HUNTINGTON.

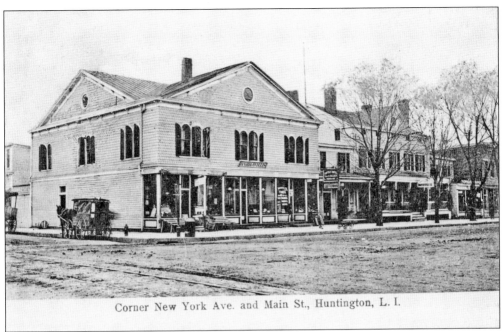

Corner New York Ave. and Main St., Huntington, L. I.

The Suffolk Hotel was built in 1840. In this postcard, it is the building behind the trees. It also at one time served as a post office. The corner building dates from 1899. On the first floor were three storefronts, and the second floor was used by the hotel for additional guest rooms. The original hotel was razed in 1927, but oddly, half of the corner building still stands.

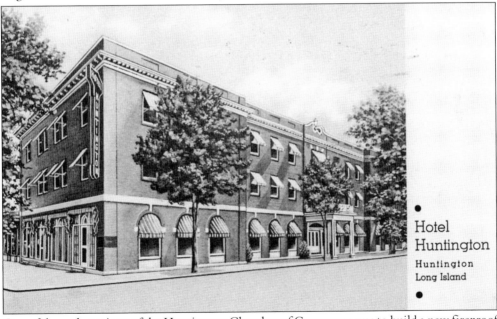

Hotel
Huntington

Huntington
Long Island

One of the early projects of the Huntington Chamber of Commerce was to build a new fireproof hotel in Huntington. The Hotel Huntington was built at the north side of the corner of New York Avenue and Fairview Street and opened on June 15, 1929. The architect was August H. Galow, who also designed the South Huntington High School. The hotel survived until 1951, and the building was razed in 2012.

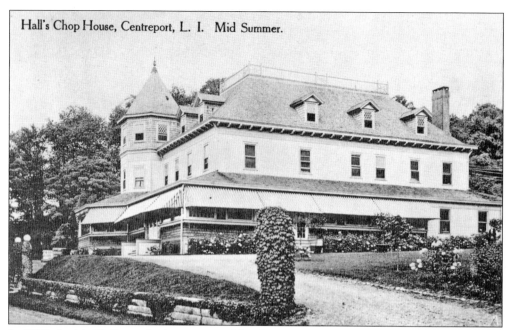

Hall's Chop House, Centreport, L. I. Mid Summer.

In 1905, Archie Hall was the last owner of the Centreport Hotel, located directly across from what is now the Centerport Post Office, near the freshwater lake. It was once called the Fabian Hostelry, one of the oldest public houses in Centerport. Hall razed the hostelry, purchased land across the street, and built Hall's Inn, which was in business by 1906. Part of the inn was the popular Hall's Chop House, where his chef served up shore dinners and duck. Archie Hall hired a superb orchestra led by Bert Hirsch and even arranged to forego cover charges for those who did not wish to dance. It was not uncommon for Hall to mail out greetings on the backs of postcards of his establishment, like the postcard below sent in 1911.

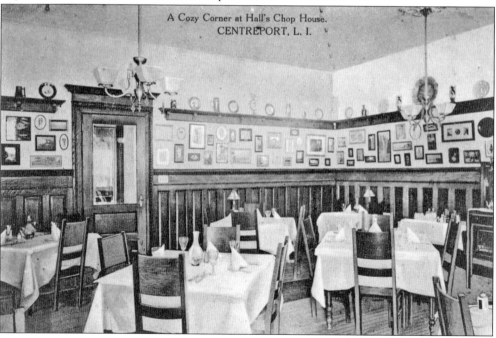

A Cozy Corner at Hall's Chop House. CENTREPORT, L. I.

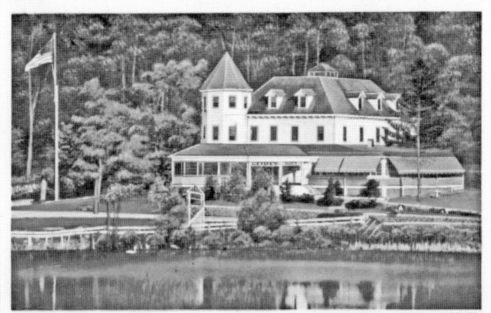

GEIDES INN, Route 25A Centerport, Long Island, N. Y.

Hall's Inn eventually became Geides Inn, named after the new owner, Walter Arthur Geide. He brought Geides Inn through World War II. In 1962, Arthur Reidel took over ownership. Four years later, the inn burned to the ground. The debris from the fire was bulldozed into a nearby pond teeming with fish, gaining a little more land for development.

This restaurant suffered from name ambiguity. Was it Roessler's or was it the Cabin Restaurant? It offered Sunday dinners for $1 and chicken and duck for $1.25. The location was 251 Main Street, Huntington, which had businesses on the upper floor as well. With street parking only, many businesses came and went, such as vacuum cleaner and clothing sales, dog grooming, Army recruiting, and the League of Women Voters.

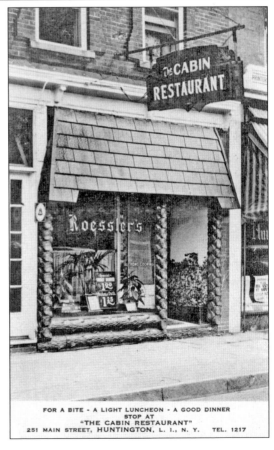

FOR A BITE - A LIGHT LUNCHEON - A GOOD DINNER
STOP AT
"THE CABIN RESTAURANT"
251 MAIN STREET, HUNTINGTON, L. I., N. Y. TEL. 1217

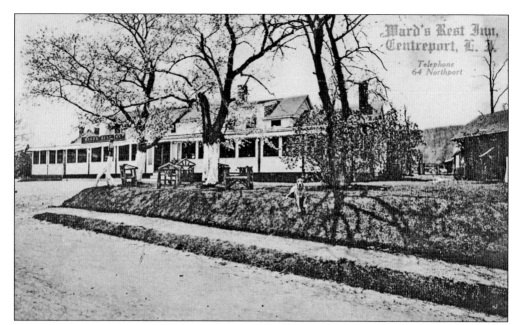

Ward's Rest Inn was Robin's Nest Inn prior to its purchase by George Ward. The inn was on the west side of Mill Pond in Centerport. Swett, the Great Dane, can be seen sitting on the front grass. According to a *Suffolk County News* report, Swett once saved a child from drowning. Ward kept the inn for 17 years until he sold it to Albert Oppikofer in 1922.

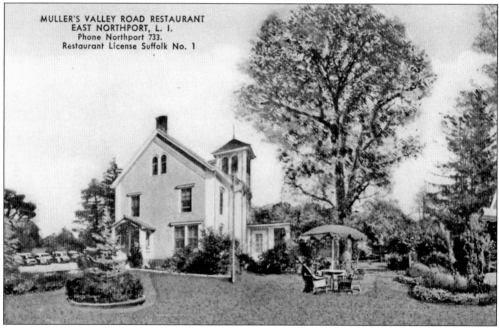

Muller's Valley Road Restaurant in East Northport was owned by Karl Muller. His wife, Wilhelmine, supervised the kitchen, the menu, and the entertainment. To its credit, the restaurant reportedly made it through Prohibition and the Depression without dismissing staff. During those difficult times, illegal gambling was a popular activity; Karl Muller was fined $50 in 1930 for having an elaborately disguised slot machine in his restaurant.

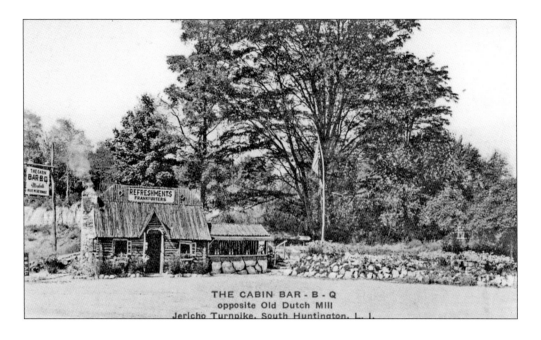

THE CABIN BAR-B-Q
opposite Old Dutch Mill
Jericho Turnpike, South Huntington, L. I.

In the 1930s, the Suffolk County Chamber of Commerce awarded cash prizes to roadside refreshment stands and automotive service stations for cleanliness, design, and even color harmonization in order to encourage these roadstands to improve their facilities. The Cabin Bar-B-Q won first prize ($50) in 1931. It was directly across from the Old Dutch Windmill at 203 East Jericho Turnpike in South Huntington. Later, the buildings were expanded (below), and the new facility was advertised as the "world's most unique roadstand" under the name of Al's Cabin. In the 1960s, it became Dolly's Log Cabin. The buildings no longer exist.

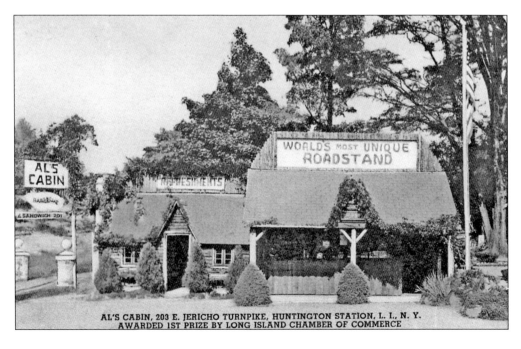

AL'S CABIN, 203 E. JERICHO TURNPIKE, HUNTINGTON STATION, L. I., N. Y.
AWARDED 1ST PRIZE BY LONG ISLAND CHAMBER OF COMMERCE

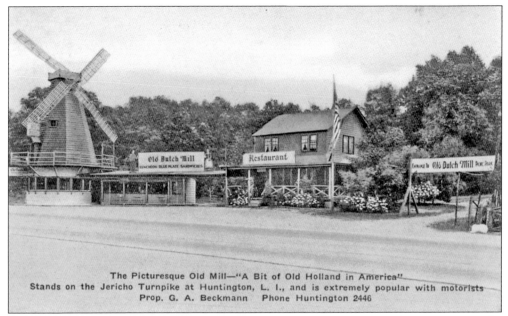

The Picturesque Old Mill—"A Bit of Old Holland in America"
Stands on the Jericho Turnpike at Huntington, L. I., and is extremely popular with motorists
Prop. G. A. Beckmann Phone Huntington 2446

The Old Dutch Mill was one of the most recognizable landmarks in South Huntington. The large windmill on the 1.75-acre plot was a directional beacon. Well known for its apple juice ("free of benzoate and preservatives") and duck dinners, ownership changed hands many times during the 1940s, mostly to women proprietors. Hsu's Dynasty took over the property in 1976, but a roof collapse cut its popularity short.

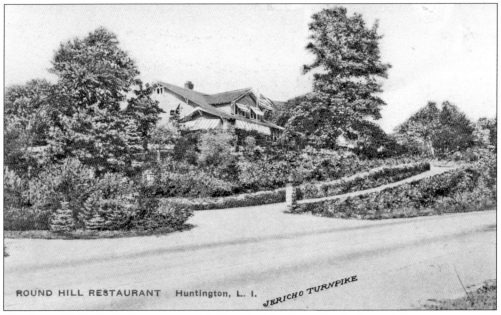

ROUND HILL RESTAURANT Huntington, L. I. JERICHO TURNPIKE

The Round Hill Restaurant was at 167 East Jericho Turnpike in South Huntington, across from today's Target. It was a place for fine wine and celebrity rendezvous. It was founded by the partnership of Bertha Pouchan and William J. and Elaine W. Broere in 1947. The property was acquired by Thomas Manno, owner of the Huntington Town House, but in May 1968, a fire gutted the establishment.

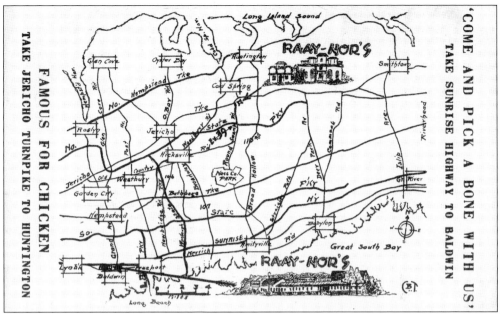

In the 1930s and 1940s, Chateau Maggi was operating at the southeast corner of Jericho Turnpike and Round Swamp Road in Huntington. The establishment was then purchased by John Vanderaay and Nora Bergin, who rechristened the restaurant Raay-Nor's Cabin. Their advertising slogan was "Come and pick a bone with us." The restaurant was famous for its Southern fried chicken and sugar–coated ham steaks. After Raay-Nor's moved to Centerport (near the corner of Highway 5A and Centershore Road), Peter Chin spotted the empty building and decided to get into the restaurant business. He opened King Wah. In 1966, there was a fire, but the restaurant reopened after repairs. The final owners renamed the restaurant Sun Ming, but it fell into disrepair and was eventually razed. The lot is currently undeveloped.

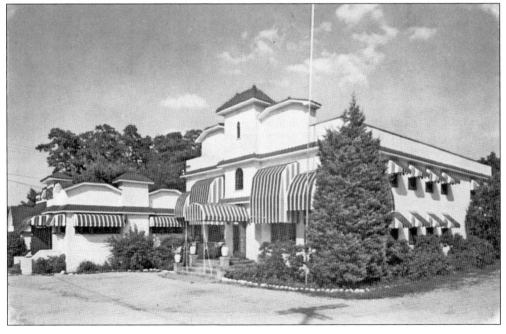

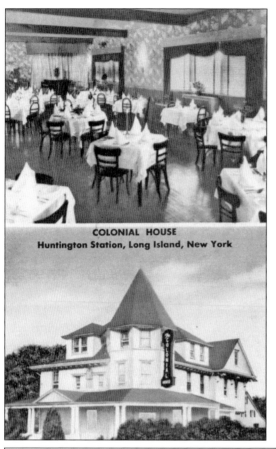

COLONIAL HOUSE
Huntington Station, Long Island, New York

The Huntington Colonial House started out as Gerlick's at the beginning of the 20th century. During its heyday in the 1950s, it was known for its French cuisine. In 1966, the Colonial House suffered the same fate in the same year as Geides Inn, Glynn's Inn, Vernon Valley Inn, and King Wah—a fire nearly gutted it. The location is now parking for railroad commuters.

The Dew Drop Inn was at the southeast corner of Jericho Turnpike and New York Avenue. It was popular for receptions, meetings, and family gatherings. It was briefly padlocked in 1929 for Prohibition violations. John and Katherine Hauser owned it from 1940 to 1949 and then sold it to John Munzel. Lastly, it was a Chinese restaurant, Mei Ting. It was eventually razed, and now a CVS occupies the site.

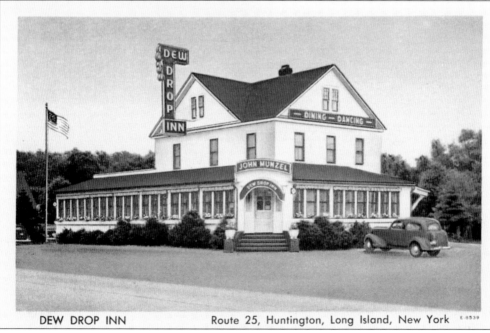

DEW DROP INN Route 25, Huntington, Long Island, New York

Five

People and Events

Many notable people have been born or lived in the Huntington area. Among them are Billy Joel, singer-songwriter; Walt Whitman, poet; Leroy Grumman, aeronautical engineer; Patti Lupone, actress and singer; Mariah Carey, singer-songwriter; Meg Whitman, business executive; Rosie O'Donnell, television personality; John Coltrane, jazz saxophonist; Edie Falco, actress; Harry Chapin, singer; and Henry L. Stimson, secretary of war during World War II.

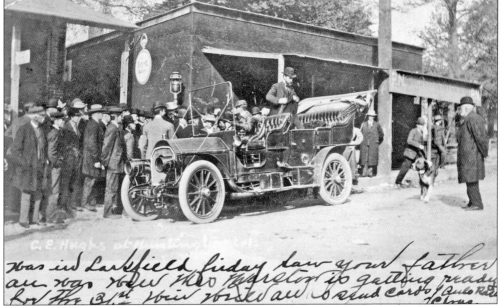

In 1906, Charles Evans Hughes visited Huntington to muster up votes for a New York gubernatorial race. He spoke at the Huntington Opera House on October 16. The *Long-Islander* wrote, "You will have the privilege of listening to the Second Lincoln." Hughes did become governor, as well as secretary of state and chief justice of the United States. He is in the light hat behind the windshield.

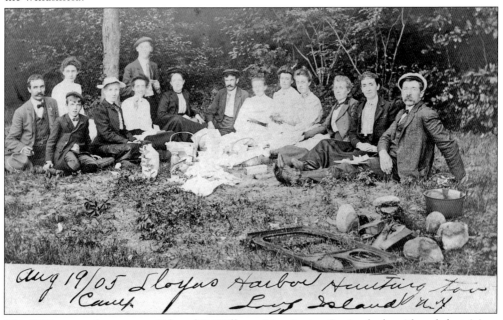

This 1905 postcard was sent to Edward B. Willets, a Huntington Station locksmith and electrician. The campers seem to have just recently completed a picnic lunch. The campfire has been extinguished. One woman is still enjoying the remains of a sandwich, and the man to the left has a freshly lit cigar. Unfortunately, the subjects of this postcard are unidentified, but a moment in Huntington social history has been captured.

This is a fine example of an image produced by James Victor Feather (1882–1950) during his time in Huntington village. Feather and his wife moved from Farmingdale to Huntington on March 1, 1907. Like Fayette Gould before him, he was a jeweler before taking up photography. He purchased Benjamin Conklin's studio on Main Street on the southwest side of the Trainer Building. He advertised heavily with clever wording such as "Better have that auto photographed while it's still new; Taken in motion if you wish." His nickname was James "Catch'em" Feather, because he always traveled with his "little black box" to catch any moment on film. He served admirably as an x-ray photographer in the Ambulance Corps in France during World War I. Postcard views were his specialty, and his work is evident throughout this book.

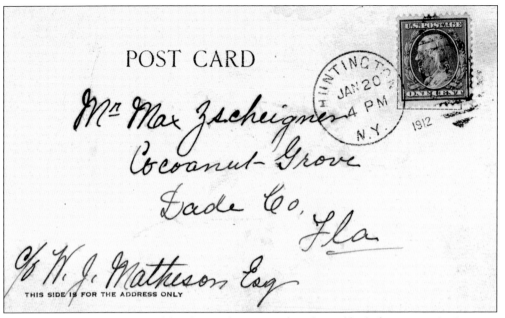

POST CARD

Mr Max Zschiegner

Cocoanut-Grove

Dade Co,

Fla

℅ W. J. Matheson Esq

THIS SIDE IS FOR THE ADDRESS ONLY

William J. Matheson was a wealthy chemical company founder and had a large estate in Coconut Grove, Florida, and a summer home atop Fort Hill in Lloyd Neck. Matheson had a large staff maintaining both estates. This postcard was sent from James Kirby, the superintendent at the Fort Hill estate, to Max Zschiegner, an engineer on Matheson's yacht, *Laverock*, in Coconut Grove. Unlike photographs, postcards can offer a wealth of additional first-hand history with the stroke of a pen. What makes this January 1912 card especially collectible is Kirby's description that one "could walk to Oyster Bay on the ice. Harbor all frozen over, and we are cutting ice 11 inches thick." Having substantial ice for the preservation of vegetables, fish, and meats would be paramount.

Lloyds Neck
1.19.12

Helo Max

Kind many thanks for card, and inquiries, glad to say Mrs K is slowly improving, after a six weeks seige of illness. If you were here now you could walk to Oyster Bay on the ice, Harbor all frozen over, and we are cutting Ice 11 inches thick, There was quite a celebration at the House last night, Nillie gave a farewell party to a lot of her Brickyard friends, they danced untill nearly two a.m. the K's & J's, excluded

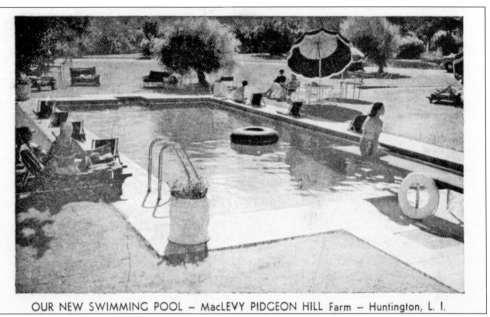

OUR NEW SWIMMING POOL – MacLEVY PIDGEON HILL Farm – Huntington, L. I.

Lillian and Maximilian MacLevy owned a chain of slenderizing salons in New York. The 108-acre Pidgeon Hill Farm was for women only with the goal to reduce, rest, and relax. For one month, women could go as often as they wished for $30. In May 1952, the estate was destroyed by fire due largely to the lack of water access near the property to fight the flames.

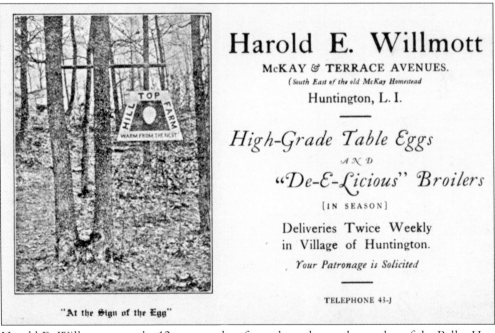

"At the Sign of the Egg"

Harold E. Willmott owned a 12-acre poultry farm along the southern edge of the Bellas Hess property. He resigned from his job as a Metropolitan Life Insurance agent to raise, show, and sell chickens and "particular eggs for particular people." His other passion was writing. Deeply committed to his community, he was a frequent contributor to the "Letters to the Editor" section of the *Long-Islander* weekly newspaper.

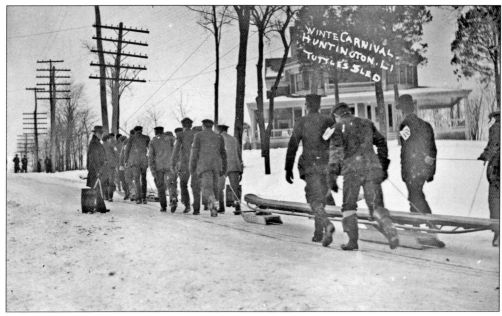

Charles H. Smith, a prominent Huntington Main Street butcher (and bobsledder) arranged a bobsled "coasting" contest between Oyster Bay, Huntington, and Cold Spring Harbor to settle the question of supremacy. On February 27, 1907, the Winter Carnival was born. The bobsled course ran from Cold Spring Hill (now Lawrence Hill Road) and down Main Street in Huntington for nearly a mile. The fire department wet down the course, and where the hoses could not reach, fire buckets full of water were used. Once the track was iced and leveled, the distance and speed contests began. The bobsled that traveled the farthest down the icy track won the top prize. Above, trudging up Cold Spring Hill is W.V. Tuttle's *Aribita* bobsled crew. The postcard below shows the *Old Hickory* bobsled, owned by James Thompson and George Brush of Huntington in 1908.

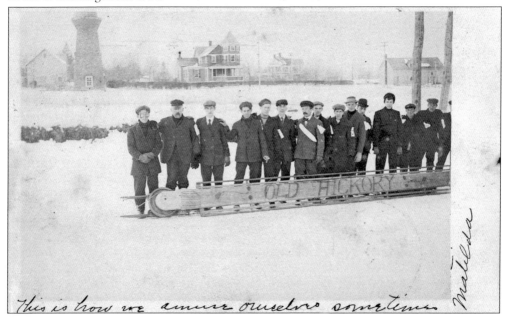

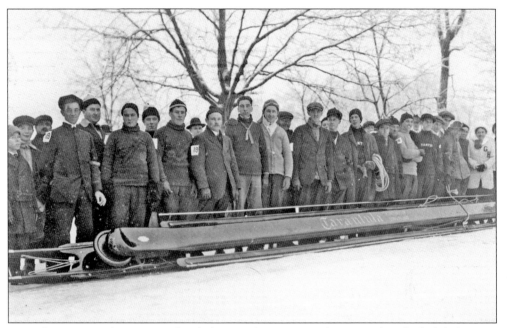

One of Huntington's most popular sleds year after year was the *Tarantula*. The bobsled was so popular with Winter Carnival visitors that even US secretary of state Henry L. Stimson, who arrived in a sleigh drawn by a pair of gray horses, requested a ride on it. In 1910, the *Tarantula* won a silver cup for the handsomest sled and crew.

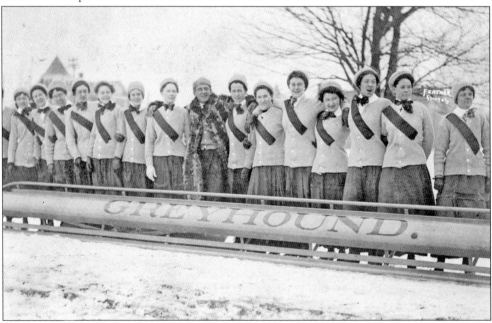

This is the all-women *Greyhound* team with the sled owner, Tom Haggerty, in the middle. During a trial run on February 6, 1920, with Haggerty steering, the sled overturned by St. Patrick's Church, hurling the sledders about. Some of the women were seriously injured, thus ending bobsled racing in Huntington. Other all-women teams competed, such as the Matinecock Neighborhood Association sled from Locust Valley, where some future races were held.

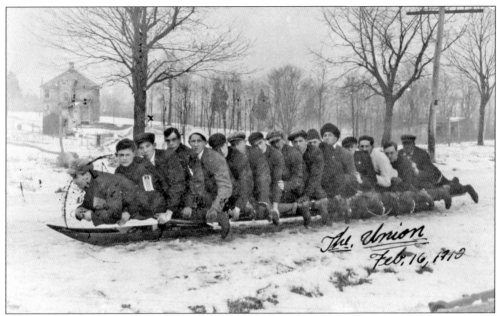

This 1910 postcard was sent by James F. Kirby, the son of the superintendent of William J. Matheson's Lloyd Neck estate, to one of Matheson's yachtsmen, Max Zschiegner, and his wife, who were at Matheson's winter estate in Coconut Grove, Florida. The *Union* bobsled was owned by Joel Hirschfield and Michael Fagan. The 19-year-old Kirby is third from the front on the bobsled.

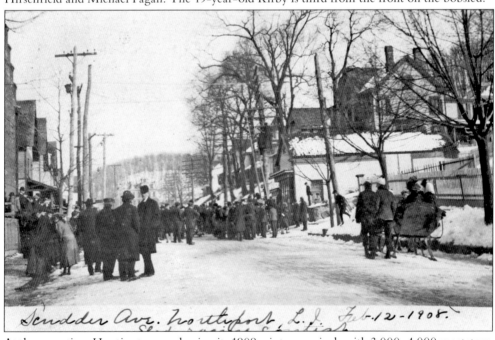

At the same time Huntington was having its 1908 winter carnival, with 3,000–4,000 spectators, Northport held a Lincoln's birthday sled carnival on Scudder Avenue witnessed by nearly 500 people. The boys on sleds raced for the prize of a large flexible flier. The girls raced for $5 in gold. Second- and third-prize winners received boxes of Huyler's chocolates. A third sled race was for adult men.

This is an 1889 government-issued postcard. Only the US Postal Service was permitted to print pre-stamped postal cards until May 19, 1898. This card, signed by a Mr. Pettit, was sent to a Mr. H. Prime to let him know that a delivery had arrived in Huntington via the Long Island Railroad. What Prime intended to do with the two boxes of stuffed birds is unknown. Taxidermy birds were certainly collectible, and stuffed birds were at one time common in fancy hats for ladies. Millions of birds were killed in the late 1880s for millinery purposes alone. In either situation, there was a ready market for stuffed birds during this period.

Form 121 3-89-3000

LONG ISLAND RAILROAD.

Huntington Station.

July 23" 1889

The following Freight consigned to your address is ready for delivery. If not removed at once, it will be stored at your expense and risk.

2 Boxes Stuffed Birds

Charges $ 3.34 which must be paid on delivery

H. O. Pettit

Agent.

FOR IDENTIFICATION BRING THIS NOTICE WITH YOU.

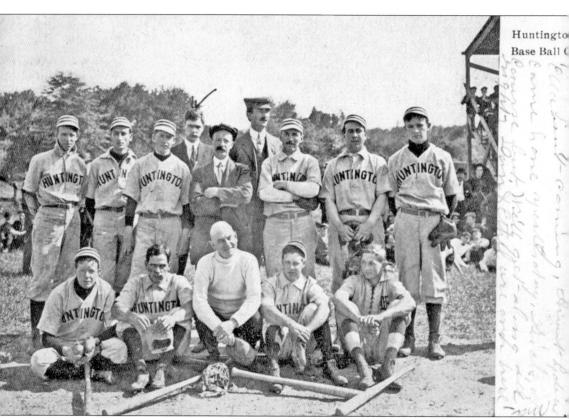

It is difficult to pinpoint the exact date that an organized baseball game was first played in Huntington. The Suffolk Baseball Club of Huntington was playing "matches" in the 1860s on the Moses Rogers property in Cold Spring Harbor, but securing adequate lots for games was difficult. Games were also played at Van Schaick's lot in east Huntington and Jennie Dusenberry Platt's lot on New York Avenue. In 1906, games were moved to the Fair Grounds Race Track due to the convenience of the trolley that stopped nearby. Matinee horse racing followed the game. Interest in baseball waned in the early 1900s but was resurrected in 1909–1910 by Dr. E.T.T. Marsh, who financially backed and organized the local Huntington Baseball Club. The club members in this postcard are identified on the back. From left to right are (sitting) F. Bunce, L. Romano, Charles A. Bigelow, Wilson Gildersleeve, and A. Klaffky; (standing) E.S. Jackson, E.V. Wilmot, D.M. Dusenberry, John F. Raynor Jr., James B.F. Thomson, H.C. Willetts, J.T. Lieper, Tom Parker, and H. Shakeshaft.

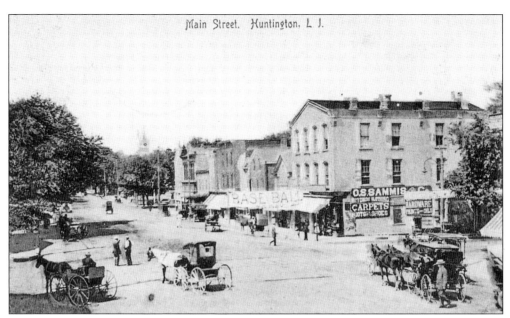

Main Street. Huntington, L.I.

The O.S. Sammis dry goods and general merchandise store can be seen at the corner of New York Avenue and Main Street in Huntington in this card postmarked 1909. This store was established in 1849 by O.S. Sammis. The Sammis family has been in Huntington since 1653. The trolley tracks can be faintly seen crossing over Main Street. Note the "Base Ball Today" banner hung across the wide road.

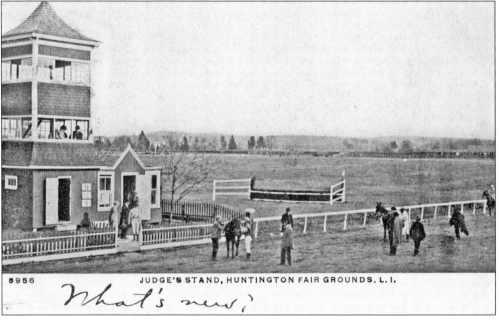

JUDGE'S STAND, HUNTINGTON FAIR GROUNDS, L.I.

The Fair Grounds Race Track was located along Depot Road by East 12th Street in what is now Huntington Station. The pre–Civil War track was also known as the Old Turkey Race Track because it was located on Fleet's Farm, which raised turkeys. The track had horse racing, livestock fairs, bicycle races, auctions, and even baseball games. The property was sold in 1925 and subdivided for housing.

The June 6, 1913, *Long-Islander* reported: "When the Cold Spring Harbor Brass Band came marching through Main Street Decoration Day morning, playing first-class music, a lady standing next to me in the crowd on the sidewalk remarked, 'Now just look at that! A little snip of a place like Cold Spring having a nice band like that and Huntington ain't even got a quartet of tin horns.' "

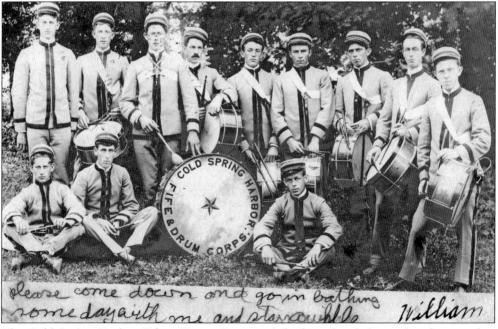

The Cold Spring Harbor Fife & Drum Corps and the brass band above played at parades, Decoration Day, and special occasions. It was often rewarded with chowder and duck meals at the local firehouses. The corps was formed in October 1902. Among the original musicians were Frank Raynor, Oscar Gardiner, Howard Gurney, Reuben Gildersleeve, and drummer Harry Cooper, who was also the leader. This card was postmarked in 1906.

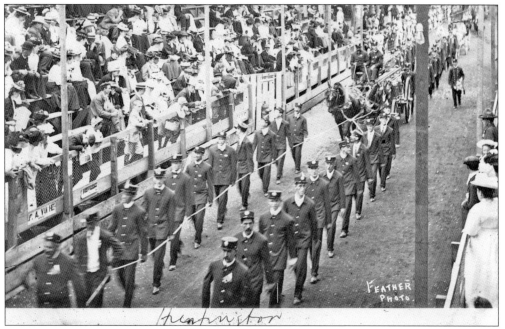

Chief Abraham Lincoln Field (later Huntington's supervisor) was a firm believer in firemen tournaments as a training mechanism for his firefighters. This postcard is one of several showing the parade of fire companies from around Long Island that competed in various speed and precision events. This is the Huntington Fire Department on parade down Main Street.

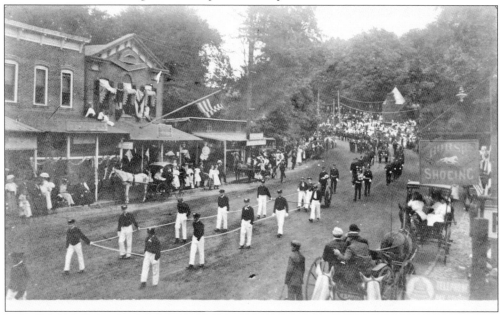

This view of the 22nd annual volunteer firemen's tournament parade (1907) shows the buildings on Main Street that would be razed in order to erect the new Huntington firehouse. Up the road is a small glimpse of the Huntington Library. According to the papers, more than 1,000 firemen marched and 10 bands provided the music. After the parade, an auctioneer sold the sawed lumber used for platforms and stands.

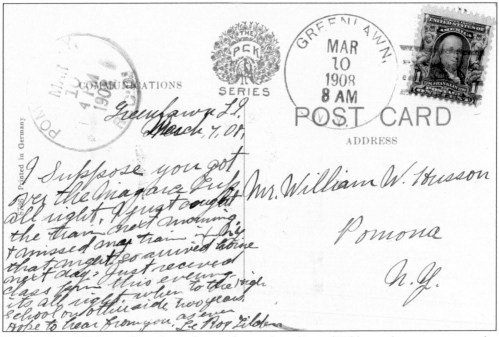

John Le Roy Tilden, a Greenlawn farmer from a long line of Tildens who were among the earliest settlers in the United States, sent the postcard above on March 10, 1908. The 40-acre Tilden farm, dating from 1793, is northwest of the Greenlawn train station near what is now Tilden Lane. According to the *Long-Islander*, "Roy" once grew "a sunflower 16 feet high by actual measurement." The postcard below has condition problems and a missing stamp but it is significant because it was sent on April 10, 1908, from an unknown person to Daisy Gardiner of Greenlawn notifying her that there were some items on sale that she might be interested in. Daisy Gardiner (who traced her roots to the *Mayflower*) and Roy Tilden were married in 1911.

92

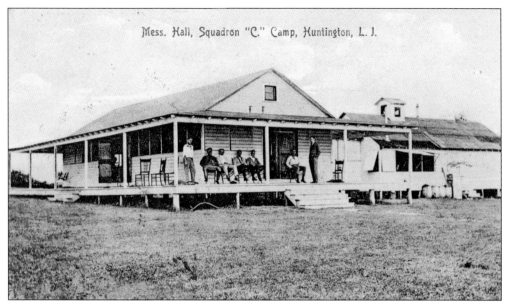

Mess. Hall, Squadron "C." Camp, Huntington, L. I.

In 1904, Brooklyn Cavalry Troop C was reorganized as Squadron C, consisting of two troops. The squadron's summer encampment was on the Moses Rogers farm property in Cold Spring Harbor, land purchased by wealthy Brooklyn members for cavalry training and socializing. The squadron was attached to the National Guard. At the time of this 1908 postcard, Pres. Theodore Roosevelt had visited the camp and troops.

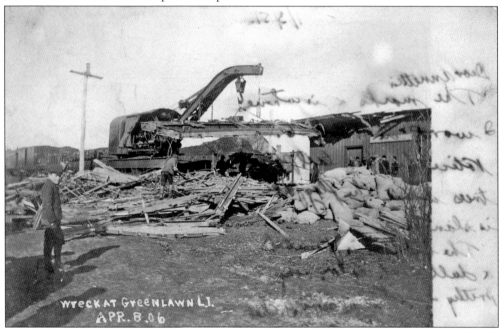

WRECK AT GREENLAWN L.I.
APR. 8.06

On Saturday afternoon, April 7, 1906, the rails spread, sending the engine of a westbound freight train off the tracks in Greenlawn. A replacement engine came in to haul the freight, but a lever got stuck, and the second engine plowed into the freight cars. Two cars were reduced to firewood and the Greenlawn depot damaged. Bags of fertilizer and the smashed freight cars can be seen in this postcard.

This early daguerreotype of Conklin Gould (December 27, 1781–November 3, 1867) was likely taken in the Plumbe Daguerrian Gallery in New York. Gould was a farmer in Lloyd Neck who made his fortune by purchasing cattle from the West, fattening them up on his Lloyd Neck farm, and then selling them in New York for a handsome profit. He once took out a notice in the *Long-Islander* forbidding people from walking and hunting on his farm because they were "leaving open gates, bars and fences, with dogs that frighten and worry our sheep, and [cattle]." Gould would often take his sheep to the slaughterhouse and tannery where Tanyard Lane and Southdown Road intersect today. Gould was a member of the association that procured the land and established the Huntington Rural Cemetery in 1851. His gravestone and that of his wife still stand just north of the cemetery office along the road. Gould was married to Ruth Sammis, another family surname firmly entrenched in Huntington history.

Six

ON THE STREETS

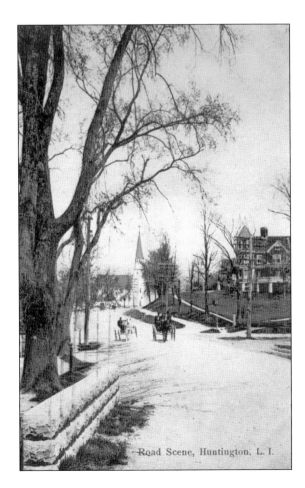

Two carriages are seen heading west toward the village of Huntington in this card postmarked 1911. The area across the street from the large home would be cleared and excavated to create Heckscher Park in 1915–1916. The Old First Presbyterian Church can be seen in the distance. The original center of the town was at one time just beyond the church near the village green.

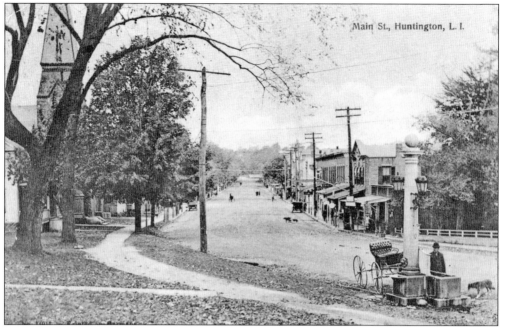

This man seems to be reading the words on the Nathan Hale Monument plaque, which still stands near the old Huntington Library. One wonders where the horse for his buggy is. A number of dogs are visible on Main Street. In 1907, after several complaints, the board of health announced that all dogs off the owner's premises needed to be muzzled.

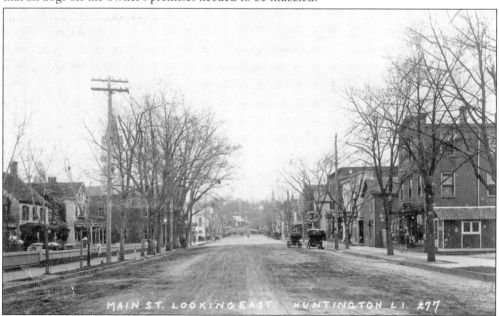

This view is looking east toward the library on Main Street, Huntington. The spire on the left is the Methodist Episcopal church, which was eventually torn down, with part of the property used to form Conklin (later Clinton) Avenue. The building just to its west would have been the office of the local newspaper, the *Long-Islander*. Eventually, the homes west of the *Long-Islander* office were relocated or torn down.

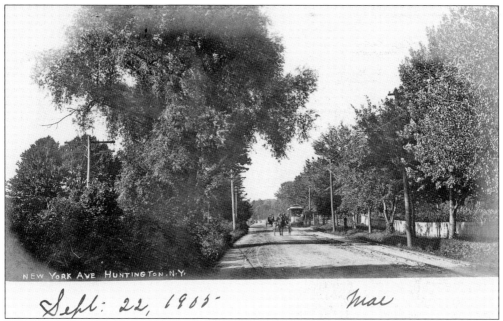

Sept. 22, 1905 *mae*

The two views here show New York Avenue in Huntington looking north. The card above was postmarked in 1905, and the one below in 1912. The trolley line ran on the east side of the avenue. The full distance from Halesite to Amityville was 18.5 miles, and the complete trip took over an hour during the electrified era. Although the roads appear to be fine, there was a real problem with dust from the pulverized gravel paving. The *Long-Islander* reported on July 19, 1912, that there was "damage to everyone's lungs by breathing the thick dust-blown clouds from the pulverized surface." Water sprinkled on the roads was a temporary solution, because it evaporated quickly. The answer was to apply a heavy coat of what was called "asphaltum" oil, which soaks in more thoroughly and lasts longer.

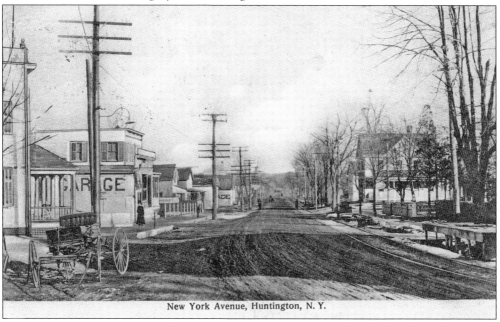

New York Avenue, Huntington, N. Y.

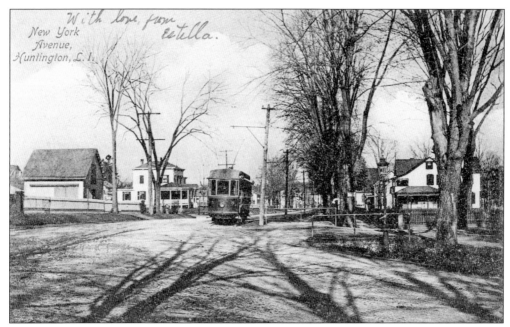

A horse-drawn trolley service along a three-mile track from Huntington Station to Halesite began on July 19, 1890. The single-car trolleys were electrified in 1898 and made their first runs in June of that year. Service on the cross-island line, which ran from Amityville to Halesite, commenced on August 25, 1909. This line was 18.5 miles long and cost 30¢ to ride the entire line. The 1906 postcard above shows the electrified one-car trolley traveling along New York Avenue at the intersection of Fairview Street. J. Hendrickson's home is on the right, and Fred Sammis's home, with the porch, is on the left. The brick culvert under Fairview Street, requested by George W. Conklin in 1897, is visible. Below, ethnic humor, sometimes proper and sometimes not, is quite common in postcards even today.

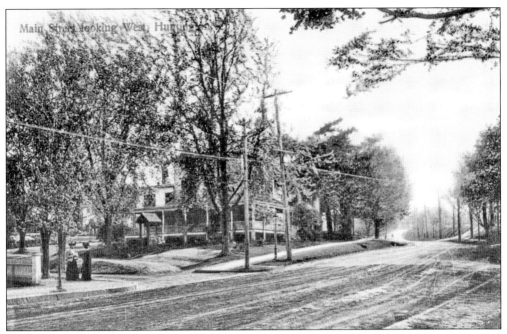

Main Street Looking West, Huntington

This 1909 postcard was sent from 17-year-old Arno Heck to his mother, Anna, in Huntington. The Hecks were farmers and owned large properties on Half Hollow Road. This image shows the home at 1 Lawrence Hill Road, which is still there. Looking west, Lawrence Hill Road is to the left. Main Street, to the right, continues to Cold Spring Harbor village.

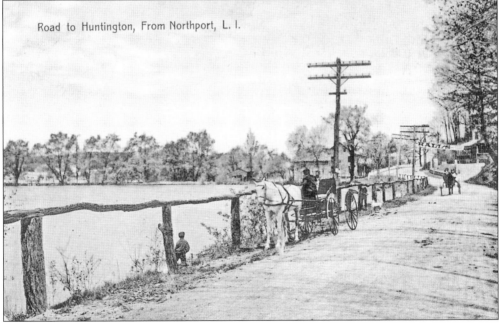

Road to Huntington, From Northport, L. I.

Thanks to the Hall's banner hung across the road, this location is clear. The water is the small freshwater lake just west of the south end of Centerport Harbor along today's Highway 25A. Hall's Chop House was across the street from the lake, about where the Centerport Post Office stands today. An old store sits across the road from Hall's. This card was postmarked in 1909.

Dewey Avenue (now Street) is on the fringe of Huntington village off New York Avenue. The first three houses still exist on the north side of Dewey at New York Avenue (above). The third house was owned and built by Stanley E. Pettit. He celebrated his new home with two hours of noise and fun, much to the irritation of neighbors. In the postcard below, the house to the right still stands on the south side at the New York Avenue corner. At the time of this 1916 postcard, Henry Borchers occupied this home. He was a grocer who sold fruits and vegetables. In April 1899, George A. Sammis planted 80 trees on Dewey Avenue. The Sammis family owned a considerable amount of property in the area, including the next block south of Dewey Avenue, which is appropriately named Sammis Street.

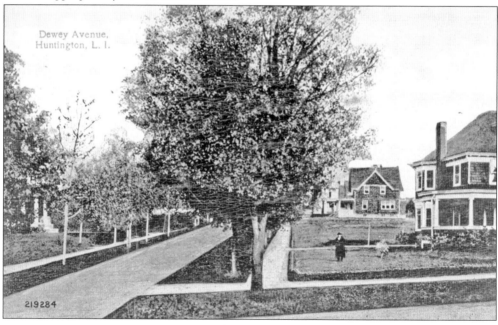

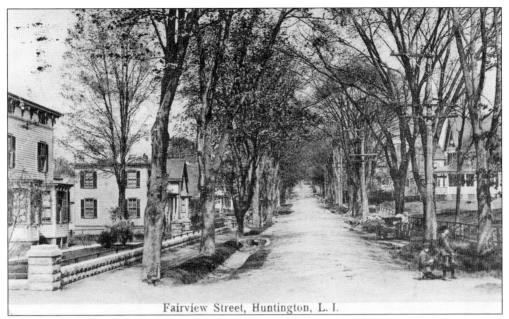

Fairview Street, Huntington, L. I.

Fairview Street is one long block north of Dewey Avenue. These postcards are similar, but the 1907 real photo postcard below shows the trolley tracks, which indicates that this photograph was taken at the corner of Fairview Street and New York Avenue. In 1914, James V. Feather and his wife set up a photograph studio on New York Avenue between Dewey Avenue and Fairview Street. Real estate and insurance agent Joseph Irwin owned two of the cottages on the left in the postcard above. Town supervisor and former fire chief A.L. Field had a home at the east end of Fairview Street. When the business district was expanded on New York Avenue in the 1920s, several houses between Carver Street and Dewey Avenue were expendable or moved. Eventually, Huntington Hotel was built at the northeast corner of New York Avenue and Fairview Street.

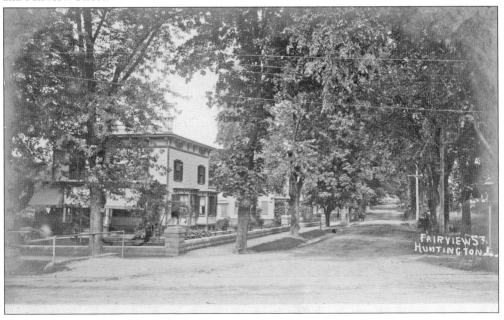

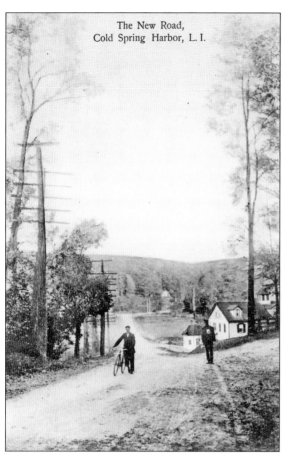

The New Road,
Cold Spring Harbor, L. I.

The new road leading west out of Cold Spring Harbor has been commonly referred to as Moore's Hill. It is still a steep and sometimes dangerous stretch of road that certainly takes strength and stamina to climb on a bicycle. One piece of lore that circulates is that wagon drivers would dump some of their unwanted wares along the side of the road for fear that their horses would not be able to pull the heavy loads up the hill. To this day, one can occasionally find shards of bottles and dishes along the shore by the road, especially after a storm reveals some of the hidden objects. Below, the new road can be seen looking west. The old road is at lower center, where two stone pillars (still standing) marked its entrance.

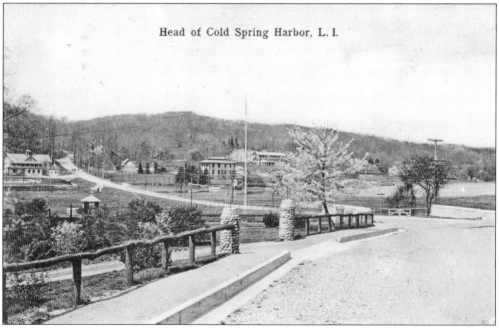

Head of Cold Spring Harbor, L. I.

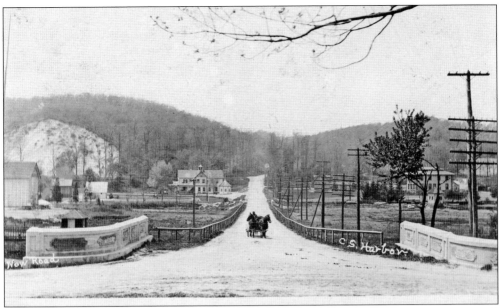

This 1909 Cold Spring Harbor postcard shows a team of horses traveling east down Moore's Hill. The fish hatchery is at center left, and the Carnegie Building of the Biological Laboratory is on the right. The outbuildings at the left were part of the Mary Jones property. The road leading right is Harbor Road, which runs through the town of Cold Spring Harbor and eventually into Main Street in Huntington.

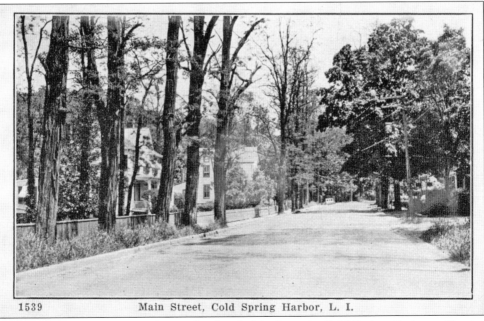

1539 Main Street, Cold Spring Harbor, L. I.

The two houses seen here, on the north side of Main Street in Cold Spring Harbor, still exist. The first house on the left belonged to James A. Kaylor, who was a traveling salesman for the Eastern Granite Roofing Company. The second house on the left belonged to the Oliver Vail Rogers family. Rogers was in the fish business. He started a lobster hatchery near Eagle Dock with eggs brought from the deep water near Rocky Point.

103

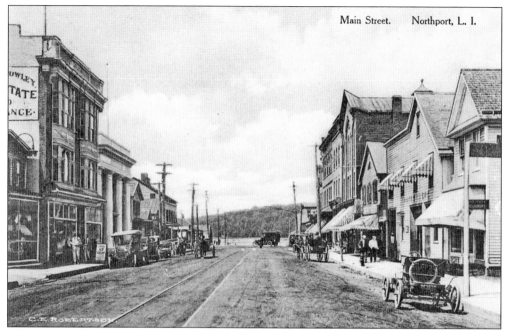

This is a view of Northport's quintessential Main Street looking west. It terminates at the harbor's edge, which in itself is a feature that draws visitors to the village. The trolley, which ran from 1902 to 1924, was such a vital entity for Northport that the village opted to retain the tracks. The first three buildings on the left and the group of tall buildings on the right still stand.

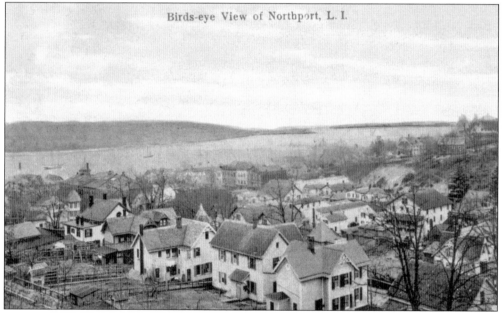

Birds-eye View of Northport, L. I.

Helen A. Robbins owned a considerable swath of property south of Main Street, east of Scudder Avenue, and north of Washington Place. This postcard shows the backyards of the homes on Washington Place, which was then in an area referred to as Washington Heights. Helen Robbins sold all the lots that the houses were built upon. At center, the large buildings on Main Street, Northport can be seen.

The first homes to the left and right still stand on Seaview Avenue, and look quite the same. This block was developed in the late 1890s. Benjamin Robbins built several houses on this block and in Northport Heights. Lawyer William B. Codling, who bought land, built, and then sold a number of homes on Asharoken Beach, was an early owner of 46 Seaview Avenue.

View of Highland Avenue, Northport, L. I.

Highland Avenue runs uphill northeast from Bayview Avenue in Northport. In 1909, there were no more than 25 homes built on Highland Avenue. At that time, the three houses on the left were owned by, from left to right, G.A. Brush, James Cockcroft, and H. Hartt. In 1917, a Mrs. Sheppard, an employee with the Edward Thompson Company, was living in the first home. This postcard was mailed in 1914.

105

AT "VON WRANGELLS"
NORTHPORT, LONG ISLAND, N. Y.

Charles von Wrangell owned the former home of oyster baron Stanley Lowndes at 155 Bayview Avenue, seen here from two angles. He was married to Leda von Wrangell, the widow of Comdr. Victor Utgoff, a highly decorated Russian naval pilot. They often entertained royalty, singers, and even the "poor little rich girl," Barbara Hutton. The von Wrangells sold the home in 1954 and moved to San Diego.

Woodbine Avenue is the long road that runs up the east side of Northport Harbor to Main Street. This view is looking south. A horse and carriage (accompanied by a dog) head toward the village. At one time, the trolley ran up Woodbine Avenue to the village; as narrow as the road is, rail transportation would be impossible up Woodbine Avenue today. The sender has dated the postcard July 4, 1908.

Seven

ALONG THE HARBORS

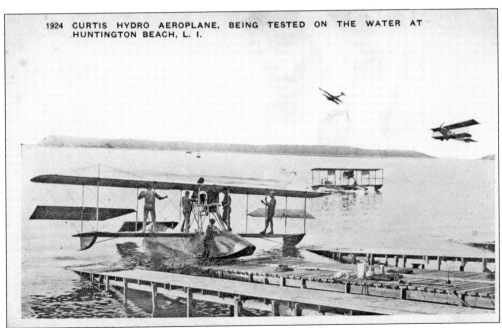

Skill, dash, and courage were the words used to describe the pilots of the Curtiss hydro-aeroplanes. In the 1910s, there was a US Naval Reserve aviation school along the shoreline property of John Cartledge of Huntington Bay where these daredevils practiced their aerial skills. Many young men trained here in preparation for dangerous service abroad during World War I.

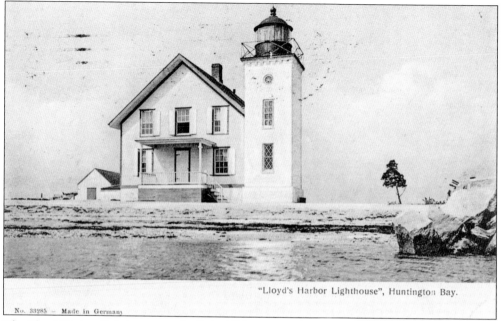

"Lloyd's Harbor Lighthouse", Huntington Bay.

The Lloyd Harbor lighthouse was built in 1857 on a sand spit. With the increase of commerce and transportation directed to Huntington Harbor, a new lighthouse, looking like a small castle, was built closer to the Huntington inlet in 1912. The original Lloyd Harbor lighthouse burned in 1947. The 1912 replacement, now called the Huntington Harbor lighthouse, is listed in the National Register of Historic Places.

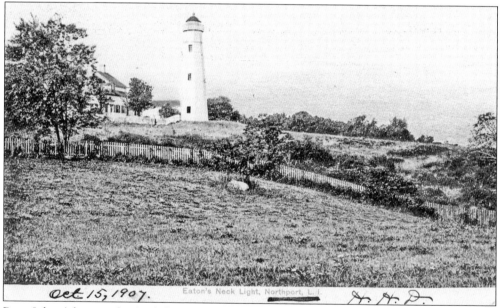

Oct 15, 1907. Eaton's Neck Light, Northport, L. I.

Pres. John Adams authorized the construction of the Eaton's Neck lighthouse in 1798. This lighthouse and the one in Montauk are the two remaining 18th-century lighthouses in New York State. Both were built by John McComb Jr., a Scottish immigrant. The Eaton's Neck light is still operational, but due to impending repairs, it is not open to the public. The US Coast Guard occupies the property.

The lighthouse in Cold Spring Harbor was built in 1890, relatively late given the large whaling boats that sailed past the dangerous shoals and into the harbor without navigational aids from the 1830s to 1850s. The wooden tower was built upon a concrete and iron caisson. The tower was removed in 1965 and relocated to private property. A steel cage replaced the tower on the caisson.

This interesting postcard from 1904–1905 is a view of Cold Spring Harbor (the west side) from the Louis Comfort Tiffany estate, Laurelton Hall, while it was under construction. A ship can be seen at a makeshift dock on the right, perhaps offloading materials to the shore. Hundreds of logs line the property to the right.

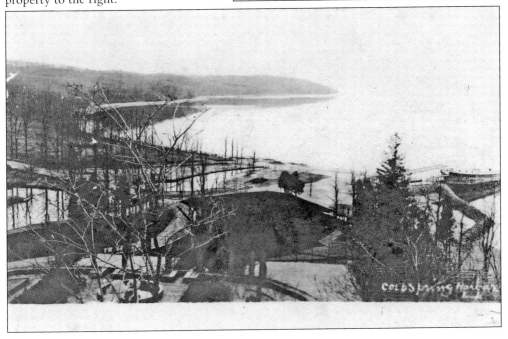

The 125-foot steamer *Huntington*, built in 1903 at a cost of $33,000, transported passengers and freight to ports in New York and Connecticut. The captain was Ira B. Young, and the ship was christened by his daughter, Hattie, in the Noank Shipyard of Connecticut. Train and automobile travel reduced its patronage and freight. The steamer was sold in 1913 and eventually used to carry freight down the Delaware River.

The unlucky steamer *Northport* carried passengers and cargo from Northport to ports in New York and Norwalk, Connecticut. In 1894, it was sunk by ice in the Northport Harbor and was refloated. In 1897, it lost its shaft and wheel and had to be towed by the *Huntington* to New York. A fire destroyed the upper deck around 1917, leaving just the metal hull, which was sold in 1918.

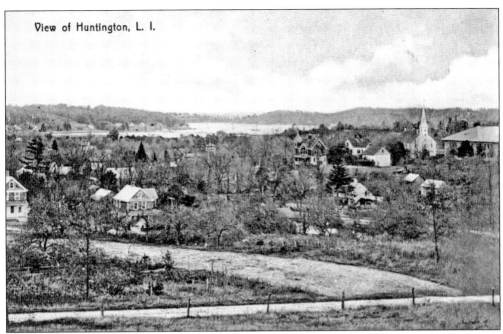

View of Huntington, L. I.

This view shows a portion of eastern Huntington village from the southwest. The Old First Presbyterian Church and the Main Street School can be seen on the far right. In the distance are Mill Pond and Huntington Harbor. This view was likely photographed from the higher property near the Huntington Rural Cemetery.

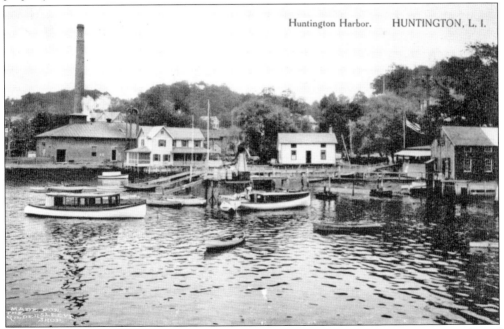

Huntington Harbor. HUNTINGTON, L. I.

The Huntington Light and Power Company was located in Halesite at the southeast edge of the harbor, where coal could be delivered by barge. The company was organized in 1902, and Henry S. Brush was elected its first president. In 1903, the 100-foot chimney was built with special curved bricks, and later that same year, the power was turned on.

lo septembre 1907

This 1907 Cold Spring Harbor postcard shows the *Ideal*, a sloop with a gaff-rigged sail that was popular at that time. Standing aft on the *Ideal* is its captain, Benjamin Doty, who occasionally took visitors on cruises about the harbor. The sender, Pierre, has written on the back in French that he has spent two months in the house up on the hill nearly hidden by the trees.

On foggy mornings in Cold Spring Harbor, one can still take a beautiful and tranquil photograph like this. This is likely a fantail launch that was popular for shuttling passengers around the harbor in the shade of the awning. About the only big news around the harbor at the time of this 1905 postcard was that the snappers were biting and the oysters abundant.

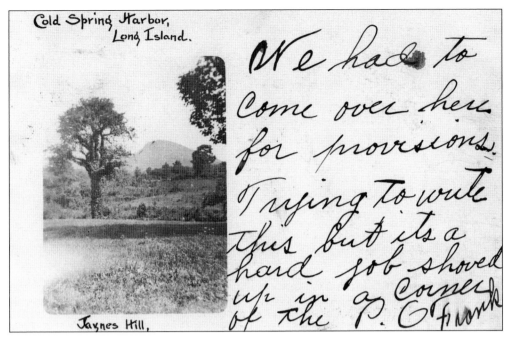

Cold Spring Harbor, Long Island.

Jaynes Hill,

We had to come over here for provisions. Trying to write this but its a hard job shoved up in a corner of the P. O. frank

These two postcards were produced by the same photographer and sent to the same person on the same day in 1905. The postcard above shows a rare view of Jayne's Hill in West Hills from a vantage point in Cold Spring Harbor, roughly three miles away. It had been called High and Oakley Hill in the past, but the current name came from the Jayne family, who occupied the area in the early 1800s. Over the years, the elevation of Jayne's Hill varied from 383 feet to its current 401 feet, making it arguably the highest point on Long Island. Below is a view of St. John's Lake from the area of St. John's Episcopal Church at the northwest corner of the lake.

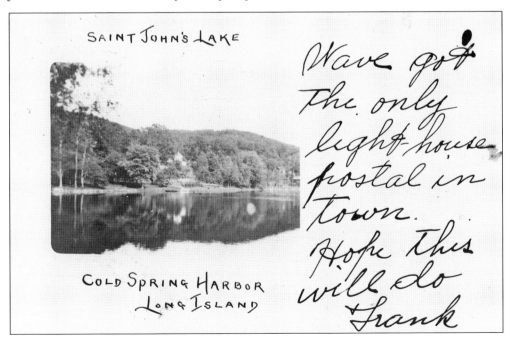

SAINT JOHN'S LAKE

COLD SPRING HARBOR
LONG ISLAND

Have got the only light-house postal in town. Hope this will do Frank

Caumsett Beach, West Neck. Huntingto. L. I.

In May 1904, Dr. Oliver L. Jones donated land at the foot of Crossman's Hill, which is the hill one travels down on West Neck Road to get to the shore. Part of that tract was Caumsett Beach. Today that beach is called Lloyd Neck Beach, and it maintains the same scenic beauty seen in this postcard.

Huntington Bay love to Edward from Uncle John

At the beginning of the 20th century, Huntington Bay was known as one of the most picturesque locations on Long Island. Wealthy individuals like August Heckscher, Milton L'Ecluse, and George Taylor purchased farm land and built their estates overlooking the bay, where they could command beautiful views for miles. Taylor, in particular, purchased 188 acres of land just to prevent developers from cutting up the area into small lots.

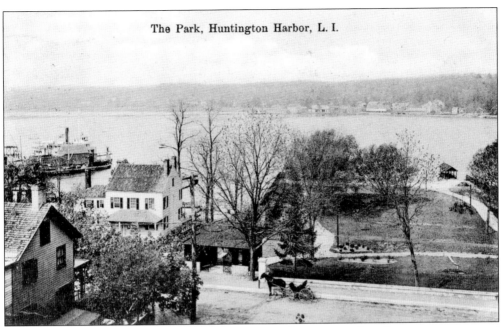

The Park, Huntington Harbor, L. I.

In 1906, a park in Halesite, on the former property of Brown Brothers Pottery, was proposed by three wealthy residents, W.J. Matheson, August Heckscher, and E.A. Smith, all of whom would be involved in the development of Huntington Hospital in the future. The park opened in 1907 and was a favorite spot for children visiting camps and Fresh Air homes in the summer. In 1979, there was great excitement, and a bit of bad behavior by teens, when a 63-foot finback whale beached itself at the public park. The carcass was towed out to sea by the Coast Guard and destroyed. The iron fencing erected by the T.E. Carpenter Company and the two park entrances on East Shore Road still remain. The beach is gone, and part of the park is now used to moor boats.

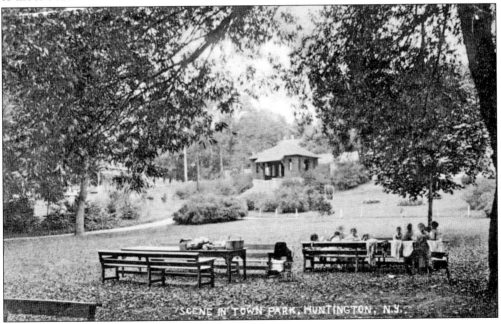

SCENE IN TOWN PARK, HUNTINGTON, N.Y.

On February 28, 1904, heavy rains caused the dam to burst at St. John's Lake. Water and debris cut off the road on the west side of the lake, the grounds of the fishery were damaged, and 85 feet of roadbed was carried off. The favorite local fishing hole on the first day of trout fishing was gone. The village milkman had to travel south past the lakes and come up by John Wolfert's hotel to get to Shore Road. Contractors, many of whom were Italian laborers, were originally hired to build a concrete bridge over the new highway (above) but were soon working on a new dam (below) as well. The fish hatchery also used the contractors to build new trout ponds using concrete for the bottoms and sides. The dam was completed in November 1904.

The Dam St. John's Lake, Cold Spring Harbor, L. I.

Cold Spring Harbor, L.I. "The Old Mill."

September seventh, nineteen five

The last few days of my vacation I am spending near here. Shall be glad to see you again

a. m. Toles

Due to its ready access to water for power, Cold Spring Harbor was known for its many mills, including saw, woolen, paper, and gristmills. The most prominent gristmill in the harbor's history dates to 1791 and was likely built by the Jones and Hewlett Company. It was on the southeast side of the harbor and consisted of four stories, with two stories below the embankment. Grains were brought to this mill by boat and wagon to be ground into flour. The water to power the mill came from St. John's Lake via a hand-dug channel along the road. A fire started in the mill in the evening of September 14, 1921, and quickly spread to other structures owned by the W.E. Jones estate, as well as several boats nearby. The mill was destroyed.

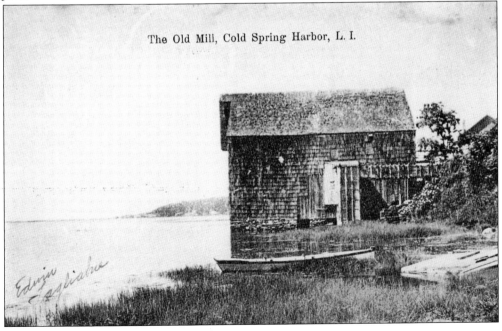

The Old Mill, Cold Spring Harbor, L. I.

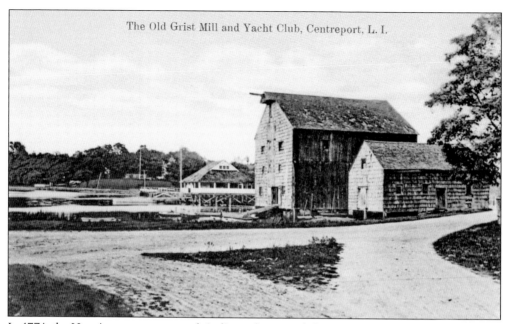

The Old Grist Mill and Yacht Club, Centreport, L. I.

In 1774, the Huntington town records indicate that permission was given to Silvanus Townsend of Oyster Bay to build a dam and gristmill on Centerport Harbor. The gristmill was located near the corner of Mill Dam and Centershore Roads. In its later days, the mill was operated by William Titus. The mill was demolished in 1915, and its structural beams were used to construct a mansion in Centerport.

Road Scene and Club House, Huntington Harbor.

No. 33186 Pub. by Gildersleeve's Studio, Huntington, N. Y. (Germany)

The Huntington Yacht Club is located on East Shore Road in Huntington, which was Harbor Road at the time of this postcard. This rustic section is the east side of Huntington Harbor looking south. Turning around and following this road north would have taken one to the Bay Crest and Harbor Hills communities and the property of August Heckscher in Wincoma.

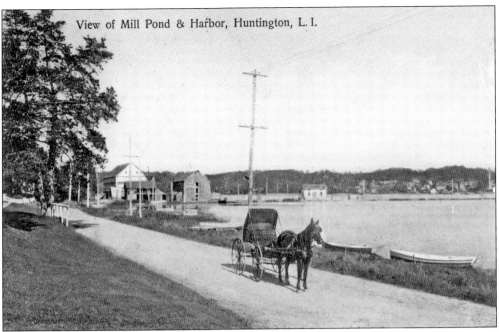

View of Mill Pond & Harbor, Huntington, L. I.

The gristmill and mill dam that were on Mill Dam Road in Huntington up until 1930 were built in 1752 by Zophar Platt. At that time, Mill Pond was significantly larger than it is today and therefore supplied more power to grind the grain. Farmers were charged a toll (in grain) based on the amount of work the miller had to do. If the miller operated a less powerful mill, then he would toil harder and therefore be paid more. The mill was demolished in 1930, and much of its good planking was used to build a mansion in Connecticut. The mill is commonly called Smith's mill, because Daniel W. Smith was the last miller. Today, the only mill left standing in the township is Van Wyck–Lefferts tide mill at an arm of Huntington Harbor at West Neck.

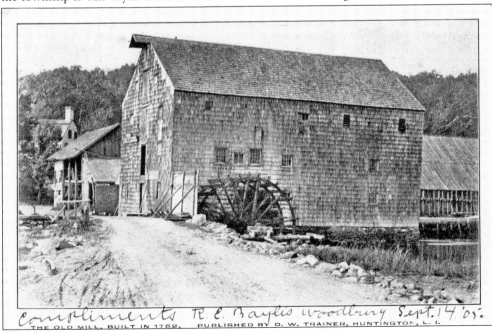

THE OLD MILL, BUILT IN 1752. PUBLISHED BY D. W. TRAINER, HUNTINGTON, L. I.

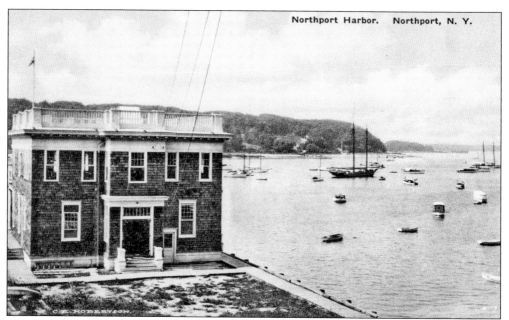

In September 1898, a group of prominent Brooklynites met in Northport and appointed committees to create bylaws and a charter for the formation of the Northport Yacht Club. The club purchased the Brewster property on Bayview Avenue and moved the house across the road onto a waterside lot. This became the clubhouse. The Northport Yacht Club was incorporated on April 10, 1899, and opened in July 1899.

The Independent Yacht Club in Northport was organized in July 1899. Construction on a new clubhouse began in September 1900 on the dock of Commodore Levinus Scudder's coal yard. In 1925, when the Northport Yacht Club ceased, the Independent took its name. During World War II, the yacht club folded, and the Edgewater Yacht Club took the name that still exists today, the Northport Yacht Club.

Huntington L. I.

a most excellent peace for the house party Dick 9/24

The Huntington Yacht Club was organized on September 20, 1894, at the home of Jay Woolsey Shepard. The constitution and bylaws were adopted at the time and published in the *Long-Islander* on September 29, 1894. The original entrance fee was $25 with $15 yearly dues. Architect William B. Tuthill drew up the plans for the clubhouse, which was erected on Ketcham's Dock about midway up the harbor on the east side. The clubhouse opened in July 1895 to much fanfare. It was decorated with Japanese lanterns and bunting. Fireworks were set off in the harbor while throngs of people watched along the waterfront. The first commodore was H.H. Gordon, and the first annual regatta was held on August 31, 1895. This building has been replaced.

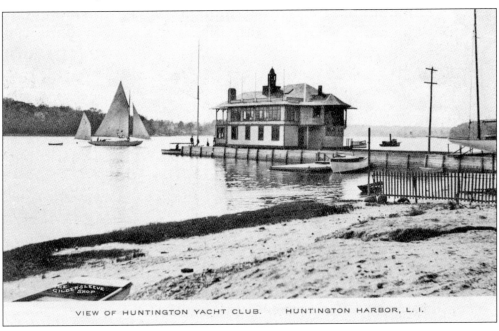

VIEW OF HUNTINGTON YACHT CLUB. HUNTINGTON HARBOR, L. I.

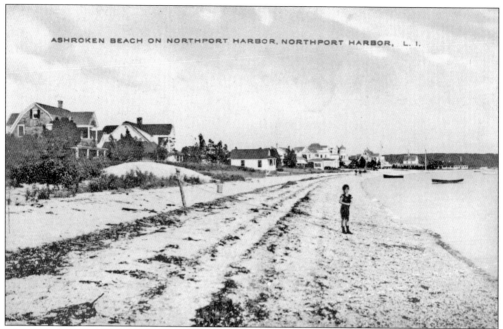

ASHROKEN BEACH ON NORTHPORT HARBOR, NORTHPORT HARBOR, L. I.

The village of Asharoken lies between Northport and Eaton's Neck and includes a long isthmus, which is Asharoken Beach. It received its name from the head of the Matinecock Indians, Chief Asharoken. Around 1910, Asharoken was primarily a destination for those wishing to escape the summer heat. Its private village had only a scattering of mansions and summer cottages. In the early 1910s, a wealthy Northport lawyer (and Asharoken home owner), William B. Codling, bought up several tracts of land on the beach. By 1914, he was advertising 26 shorefront homes for sale. The increase of motorcars brought unwanted bathers to the beautiful beach. They disrupted the quiet colony by parking on the public road and dressing and undressing in the bushes. Nevertheless, Asharoken is still a summer resort for those who can afford it.

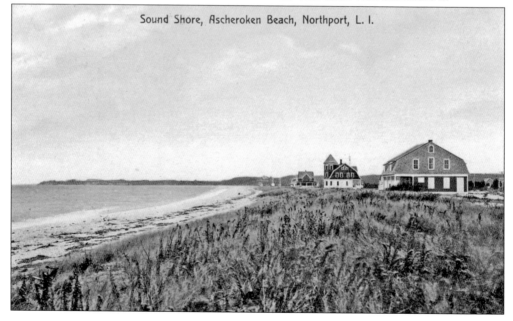

Sound Shore, Ascheroken Beach, Northport, L. I.

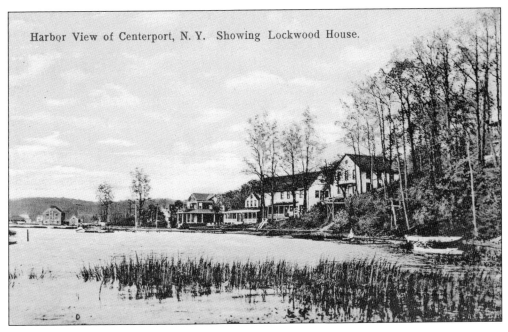

Harbor View of Centerport, N. Y. Showing Lockwood House.

The Lockwood House is the large white building in the center of the above postcard. It was on the west side of Centerport Harbor, about 100 yards north of Mill Dam. It was in use as a long- and short-term boardinghouse from about 1902 to 1930. Bathing, fishing, boating, and home cooking were offered to visitors. Those interested in staying there could request its rates and a photograph, which was probably a postcard like one of these. In the distance is the old gristmill. The original house burned down on December 16, 1912, and was rebuilt. In its later days, it was known as Harry's Inn (owned by Harry Garofallou), and it burned down again on December 22, 1930.

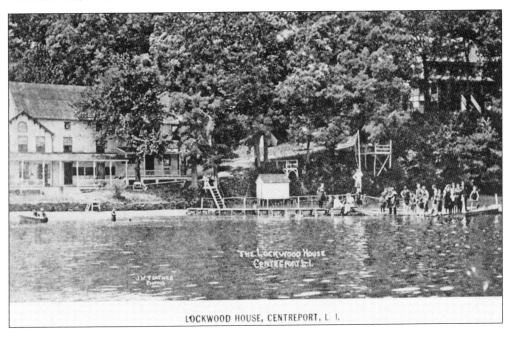

LOCKWOOD HOUSE, CENTREPORT, L. I.

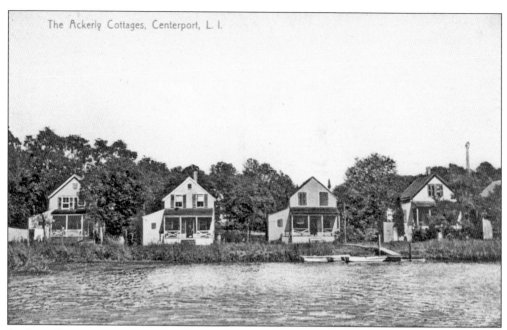

The Ackerly Cottages, Centerport, L. I.

In the early 1900s, the Ackerly family owned a number of summer cottages on the east side of Mill Lake in Centerport Harbor, along Prospect Avenue. Hiram Ackerly and E.R. Ackerly had residences directly across the street. To escape the summer heat, visitors would rent the breezy cottages for extended periods during the June-to-September season.

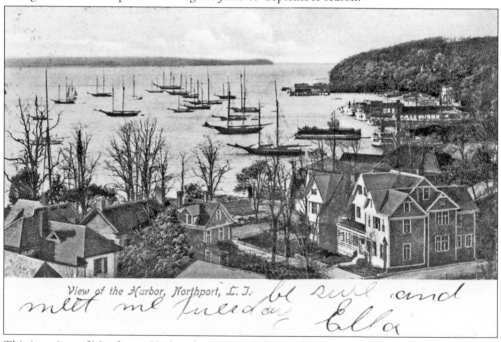

View of the Harbor, Northport, L. I.

This is a view of Northport Harbor from around the northern terminus of today's Sunset Hill. It shows the corner of Woodbine and Fifth Avenues. At the time of this postcard (1907), the small house on the southwest corner was owned by Devine Sammis. The two large houses on the right were owned by George Babcock (left) and Charles Sammis.

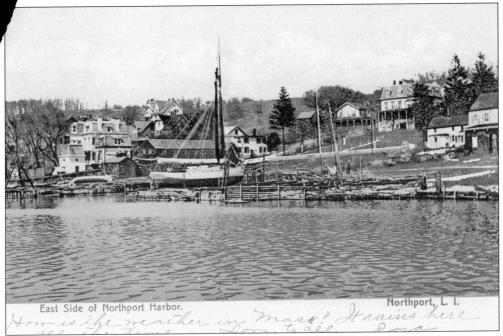

East Side of Northport Harbor. Northport, L. I.

How is the weather in mass? It rains here
all the time ... from ... Cora

Shipbuilding had declined in Northport by the time of this 1907 postcard. The dockyards here were replaced by the Northport Park in 1932. The building at left is 63 Bayview Avenue, the former home of Edward Thompson. The tall house at upper right (52 Bayview Avenue) was owned by Jesse Carll. It is now an apartment building. To its left is 56 Bayview Avenue, the former home of Aaron Jarvis.

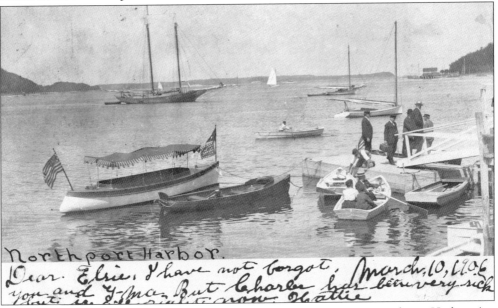

Northport Harbor.

Dear Elsie, I have not forgot, March, 10, 1906
you and I ma. But Charles has been very sick
that is ... now Hattie

The well-dressed people in this postcard are arriving by rowboats at a Northport Harbor pier. The two-masted schooner anchored in the harbor is typical of what might have been built in Northport's own shipyards during the wooden-hull era. Northport's most successful ship builder was Jesse Carll, whose shipyard was at the junction of Main Street and Bayview Avenue.

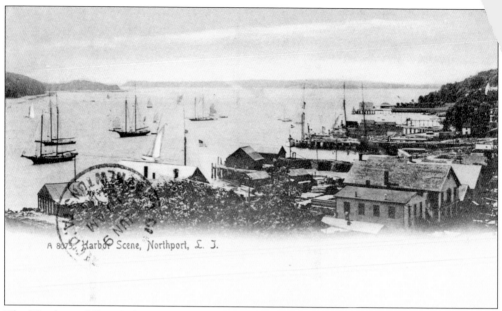

A 8075 Harbor Scene, Northport, L. J.

The Northport Historical Society has in its collection original photographs of the two halftone postcards on this page. The postcard above, mailed in 1905, has been attributed to an 1898 photograph of a harbor scene including schooners at anchor, early docks, and the barely visible Woodbine Avenue. The postcard below is a bathing scene on a sandbar near what is Scudder Park today. In 1909, residents of Northport petitioned the town to dedicate the land known as Harvey's Beach as a public park, but ownership of the strip of land and the shorefront was under dispute. The town thought that Hewlett Scudder leased that strip of shorefront from it, but Scudder claimed that he owned the beach, and that only the sandbar (the land below the high–water mark) was leased from the town.

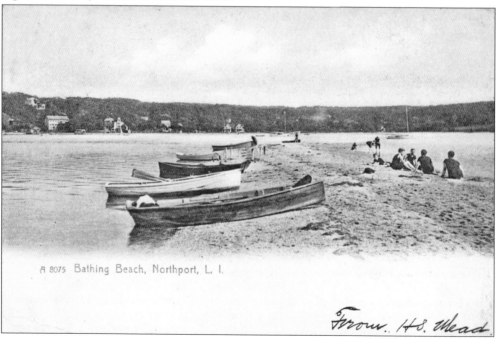

A 8075 Bathing Beach, Northport, L. I.

From. H.S. Mead

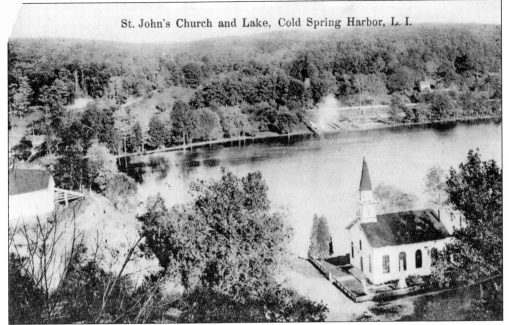

St. John's Church and Lake, Cold Spring Harbor, L. I.

This is St. John's Episcopal Church and lake in Cold Spring Harbor. Although not permitted today, ice skating on this lake was a favorite winter activity up through the 1960s. The building on the left is an old mill on the Jones property, which was used by the fish hatchery in its early years. The Jones family donated the land and money needed for the church.

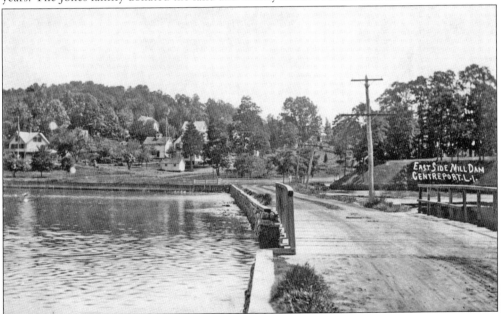

This wonderful early postcard from Centerport (note the early spelling of the village) shows the east side of Mill Dam Road, which separates Mill Pond from Centerport Harbor. Today, the property at the end of the road is occupied by a Roman Catholic church, Our Lady Queen of Martyrs. That property, with its buildings, was previously owned by Regina Brunswick, who donated all of it to establish the parish.

127

Discover Thousands of Local History Books Featuring Millions of Vintage Images

Arcadia Publishing, the leading local history publisher in the United States, is committed to making history accessible and meaningful through publishing books that celebrate and preserve the heritage of America's people and places.

Find more books like this at
www.arcadiapublishing.com

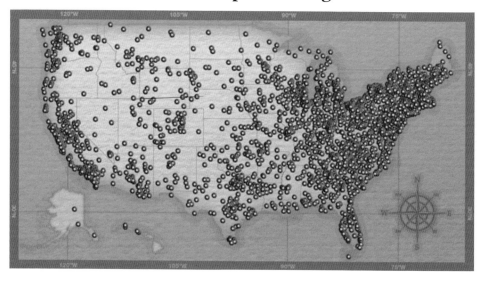

Search for your hometown history, your old stomping grounds, and even your favorite sports team.